IMAGES
of America

LIGHTHOUSES OF
SOUTHWEST MICHIGAN

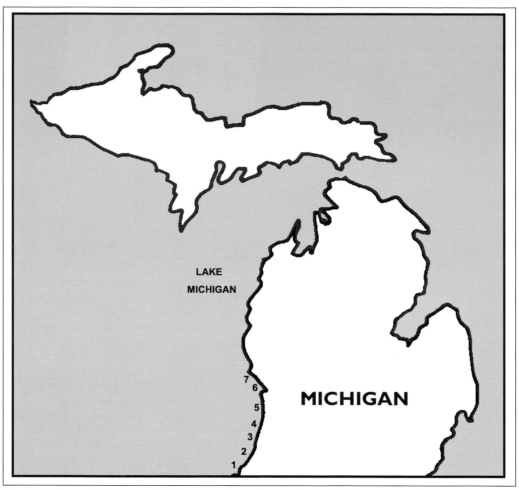

The locations of the seven lighthouses along the southwest Michigan coastline are shown on the map above: 1. St. Joseph, 2. South Haven, 3. Saugatuck, 4. Holland, 5. Grand Haven, 6. Muskegon, and 7. White River.

IMAGES
of America

LIGHTHOUSES OF
SOUTHWEST MICHIGAN

Susan Roark Hoyt

ARCADIA
PUBLISHING

Published by Arcadia Publishing
Charleston, South Carolina

Printed in the United States of America

Library of Congress Catalog Card Number: 2003105121

For all general information contact Arcadia Publishing at:
Telephone 843-853-2070
Fax 843-853-0044
E-mail sales@arcadiapublishing.com
For customer service and orders:
Toll-Free 1-888-313-2665

Visit us on the Internet at www.arcadiapublishing.com

This book is dedicated to the True Light who is able to rescue perishing souls.

CONTENTS

ACKNOWLEDGMENTS

There are many people to whom I am indebted for the completion of this book. I thank my loving husband, Tim, for his sustaining support, for spending his summers "lighthouse hunting" with me and for accompanying me as I traveled to gather material. It has been an exciting adventure. I am thankful for my dear friends Marlene and Colleen who held me accountable to my goals and encouraged me in ways too numerous to count. Their friendship is priceless. I am grateful to my parents, who through their own interest introduced me to the fascinating world of lighthouses.

Gathering material for this book was accomplished through the aid of generous individuals and institutions. A special thanks to Jeanette Hall (JH), and Lois Jesiek Kayes (LJK), for sharing their personal collections of photos. I enjoyed spending time with each of them. Thank you to Barbara Martin and the Muskegon County Museum (MCM). It was a joy to work with Barbara and to glean information from her vast wealth of knowledge. Thank you to Judy Schlaack and Sheri Lemon at the Michigan Maritime Museum (MMM). Their kindness and cooperation made researching fun. Other institutions that contributed substantially to this project include: State Archives of Michigan, Tri-Cities Historical Museum (TCHM), Fort Miami Heritage Society, (FMHS), and Holland Historical Trust.

INTRODUCTION

From the earliest days of their settlement, the coastal towns of southwest Michigan have relied heavily on Lake Michigan for their economic growth. Before Michigan became a state, in 1837, towns on the shoreline were shipping lumber and fruit to markets across the lake. As settlement continued to spread, the demand for these commodities and other agricultural products soared, bringing increased shipping traffic into the area. Many of the harbors were not adequately developed to handle this traffic. Their entrances were often hard to see from the lake, and blowing, shifting sands created sandbars in the channel, diverting channel entrances and making it dangerous for incoming vessels.

Early development of harbors and lights was primarily accomplished by local businessmen who needed good waterways to support their businesses. They dredged harbors and put up rustic lights to give mariners a general idea of the harbor location. However, these lights proved to be only minimally helpful, because they were subject to constant decay and erosion and they did not accurately identify safe entry routes. As a result, many vessels crashed or became grounded on the sand before they entered the channel.

The ongoing expense of maintaining lights and harbors was more than the fledgling communities could handle and constant pleas for federal assistance were made. However, government control of harbors was disorganized and corrupt in the beginning, and did not prove successful until the establishment of the Lighthouse Board in 1852. Once government funding became available, harbors were slowly improved, piers were extended out into the lake, and lighthouses containing living quarters for a keeper and his family were built.

To maintain these lighthouses, men of valor who had previous maritime experience or who had proven themselves in war were often chosen as keepers. Theirs was a life of tedium and danger. A long list of rules had to be adhered to at all times. Among these rules were precise directions for daily operation and maintenance of the light, instructions for keeping the house and grounds, and requirements for recording weather and lake activity in a daily log. Fulfilling these duties took much of the keeper's day. Yet, in the midst of this routine he was also ready to risk his life at a moment's notice. When ships foundered in high seas or crashed off shore, the keeper gave his utmost to rescue and care for perishing souls.

Though his efforts were valiant and many lives were saved, the lighthouse keeper did not have the necessary equipment or man power to handle large shore-based rescues. To aid with this crisis, the government established the U.S. Life-Saving Service in 1871. Their motto was: "You have to go out but you don't have to come back." These brave men, who later became known as the U.S. Coast Guard, were a valuable asset to the life-saving efforts on the lake.

Through the years, as government funding continued and economic growth prospered, many changes occurred in the harbor. Piers were lengthened and shortened and pier lights

were moved accordingly. Various harbor configurations were built to help calm entry waters. Lighthouses were remodeled and their lights were enhanced to afford greater visibility. Through all the changes, the light of the beacon remained a constant ray of hope to the foundering, and a warm welcome to the weary traveler.

One

THE LIGHTS OF
ST. JOSEPH

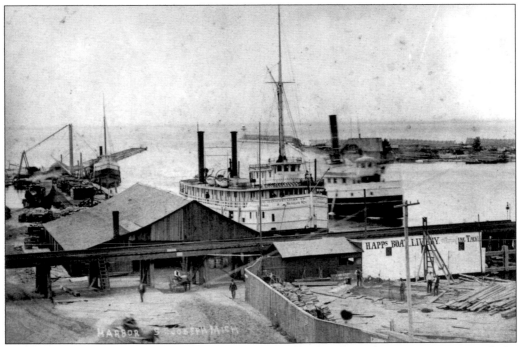

St. Joseph Harbor lies at the mouth of the St. Joseph River, where the river empties into Lake Michigan. Located in the hub of Michigan's fruit growing area, the harbor was first used for shipping fruit and other farm products. Later, it also became known as a resort harbor, bringing people from across the lake to the city of St. Joseph.

To help guide mariners safely into port, a light was built on a bluff overlooking the harbor in 1832, five years before Michigan became a state. This 40-foot-tall circular stone tower was the first Michigan light to be built on Lake Michigan.

In 1835, Congress appropriated funds to improve the harbor and the first piers were built. Eleven years later a wooden tower light was placed on the end of the north pier to assist the bluff light. The old pier light can be seen in the background in the middle of this picture of the harbor. (FMHS)

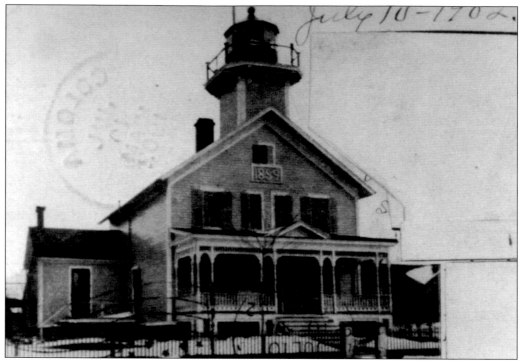

In 1859, a new lighthouse was built on the bluff to replace the original bluff light. It held a tower and light on its roof and provided dwelling space for a keeper, his family, and an assistant. One of the first keepers in this house was a woman named Slatira B. Carlton, who assumed keeper's responsibilities for a brief time after her husband died. Sadly, this lighthouse was demolished in 1950 to make way for a parking lot. (FMHS)

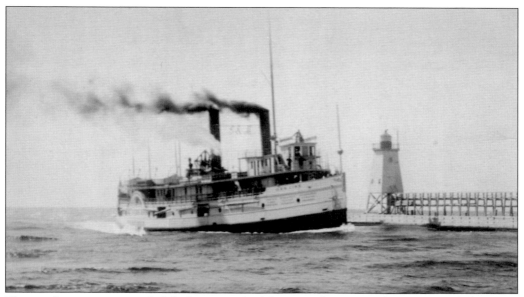

The north pier was extended farther into the lake several times in the 1880s, and the tower was moved or rebuilt along with it. This postcard shows a steamship passing the rebuilt wooden tower and catwalk. (FMHS)

10

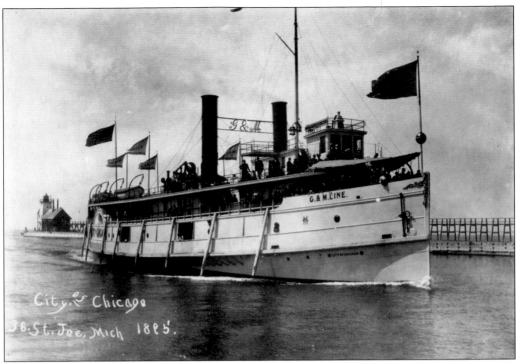

During the late 1890s, the fog signal building was added to the north pier behind the light tower. Each fog horn on the lake had a distinctive blast that aided sailors in identifying which harbor they were near when fog hid the shoreline from view. Above, the Graham & Morton Line's *City of Chicago* passes the fog horn as it enters the harbor. (FMHS)

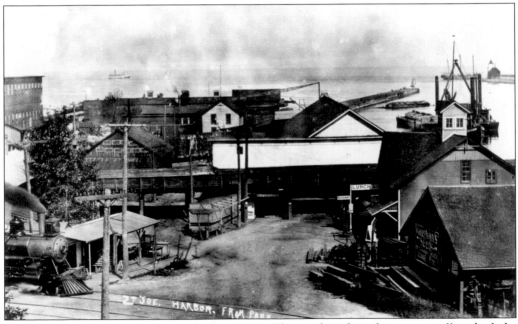

This view overlooks the harbor in the late 1890s. The north and south piers, as well as the light and fog horn can be seen on the far right of the picture. (FMHS)

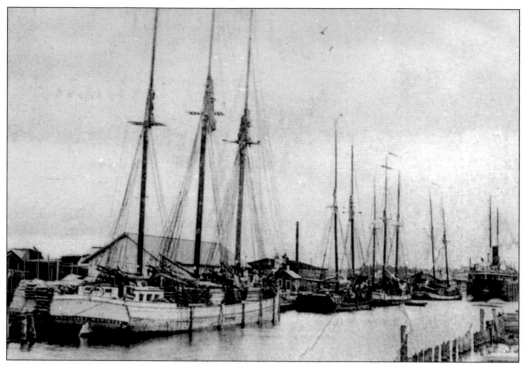

The steamer *Chicora* is seen on the far right as it is in transit in the harbor. The *Chicora* was a magnificent ship used for transporting cargo between St. Joseph and Milwaukee. On January 21, 1895 she left St. Joseph en route to Milwaukee to pick up a load of flour for transshipment. Shortly after leaving, she was caught in an ice and snow storm and was blown off course and disappeared. For the next year, bags of flour and wreckage washed up on shore but no bodies were ever found. (FMHS)

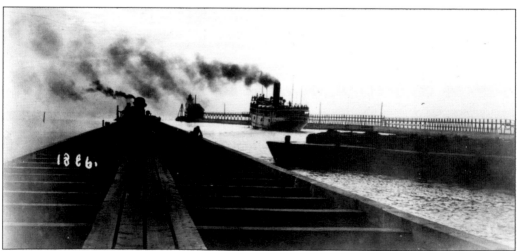

A raised catwalk ran the length of the north pier. When storm-driven waves washed over the pier, the catwalk allowed the keeper to walk above the waves in order to reach his destination safely. The south pier was a crib-like structure. It was made of wood and filled with stones for stability. Wooden planks were laid down the center of the open crib to make a walkway for pedestrians. (FMHS)

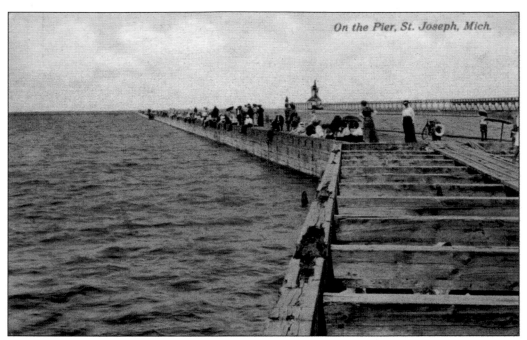

On the Pier, St. Joseph, Mich.

Fishing from the pier was popular near the turn of the century. Yellow perch were abundant during this time and were often caught and used for Friday night fish fries. (MMM)

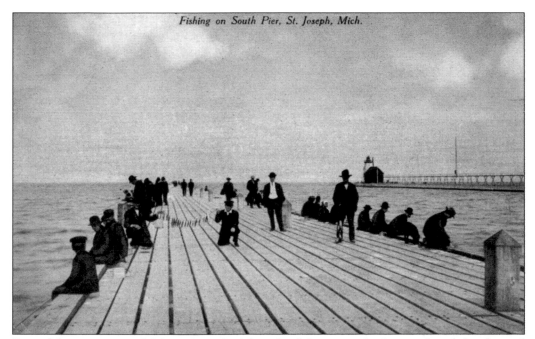

Fishing on South Pier, St. Joseph, Mich.

Some fishermen enjoyed fishing from the lake side of the pier and others preferred the channel side. While others continued fishing, these two men were glad to take a break and display their catch of the day to the photographer. (MMM)

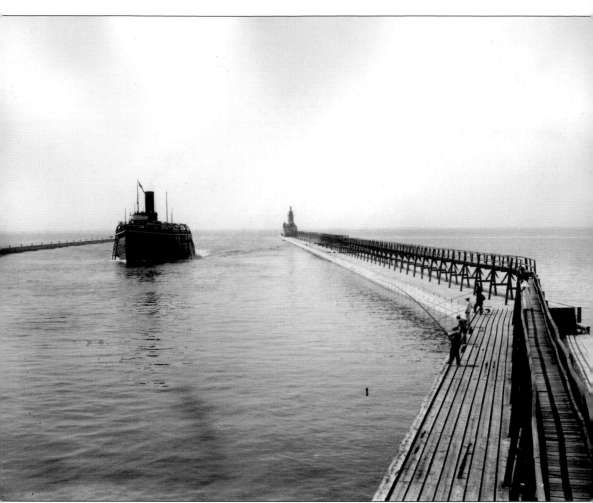

Watching activity in the channel was entertaining while waiting for fish to bite. However, a large vessel entering the harbor could go completely unnoticed when a fisherman was reeling in his catch. Above, a couple strolling on the catwalk interrupts their walk to watch a fisherman land a fish. (FMHS)

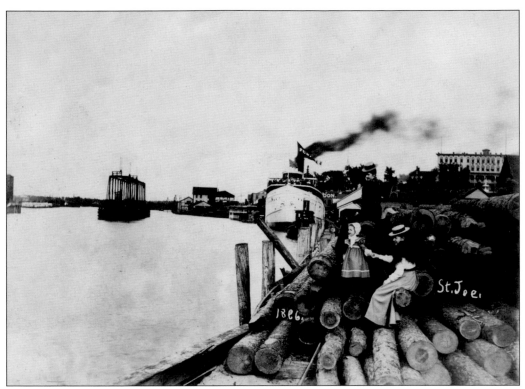

The swinging train bridge, on the left, opened to allow boats to travel up and down the river and closed to enable trains to carry their loads across the river. (FMHS)

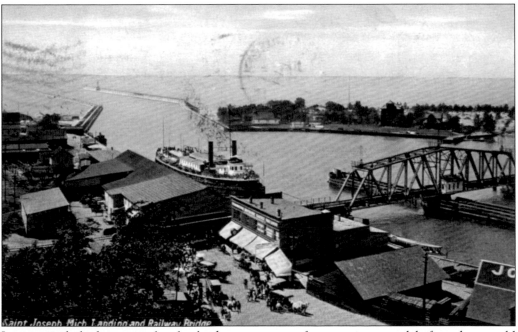

Large vessels had to wait for the bridge to reopen after a train crossed before they could continue their journey upriver to load or unload their goods. (MMM)

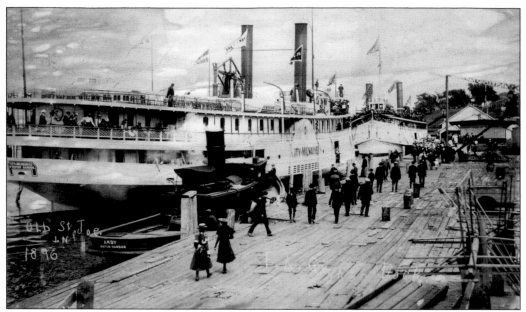

St. Joseph harbor was bustling with tourist activity in the late 1800s. Tourists arriving for a visit and those waiting to return home lined the docks. The steamer *City of Milwaukee*, seen at the dock, was one of the popular passenger ships of the time. (FMHS)

Above the harbor, fishing, boating, and just relaxing near the cool water of the river were wonderful ways for tourists to enjoy a lazy summer afternoon. (FMHS)

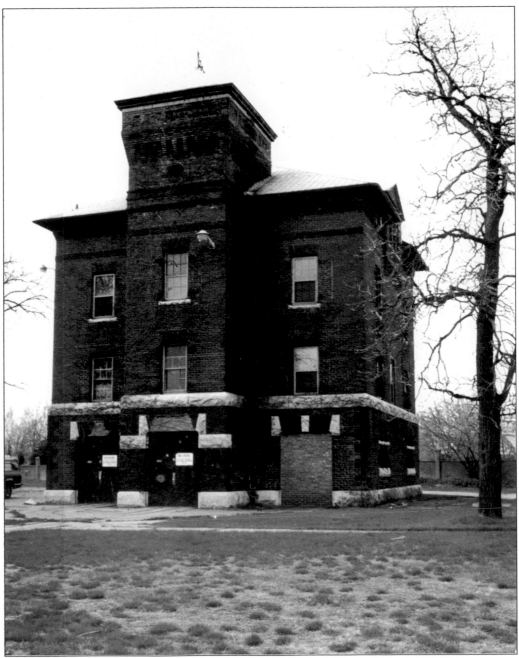

The Ninth District Lighthouse Depot was built in St. Joseph in 1893. It stored and shipped all supplies for the lighthouses in its area and also maintained navigational buoys. Inside the square tower was a spiral stairway similar to those in the lighthouses. The depot had a keeper, a lampist, and a carpenter on site to perform necessary repairs to damaged equipment. (FMHS)

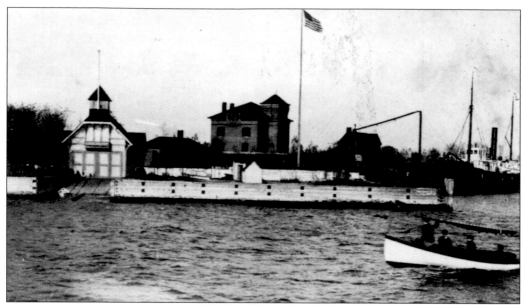

The Lighthouse Depot complex is seen in the background of the picture. Supply boats, on the right, were used to carry supplies to the various lighthouses. The life-saving station is seen in front of the depot with members of its crew in the foreground practicing drills in their boat. (State Archives of Michigan.)

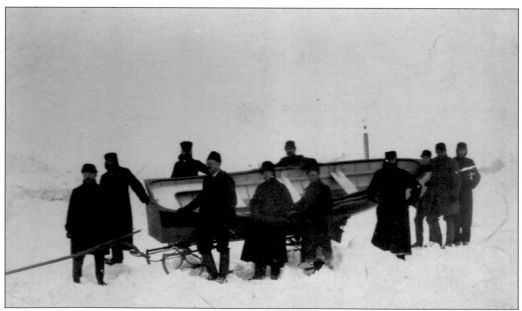

The Life-Saving Service eventually merged with the Revenue Cutter Service to form the U.S. Coast Guard. Below, members of the Coast Guard pull their lifeboat to the water on a sled during winter drills. (FMHS)

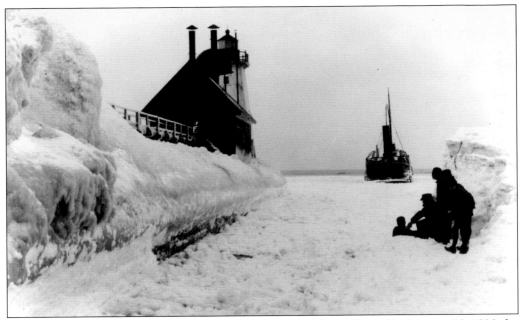

The sandbars near St. Joe harbor caused many wrecks and loss of lives. On January 26, 1898 the *City of Duluth* was trying to enter the harbor during a storm and hit a sandbar. The captain ordered her engines at full speed, hoping that the next swell would lift her off the bar. Instead, it ground her deeper into the sand, where she sat for the next hour until she was finally blown free. (FMHS)

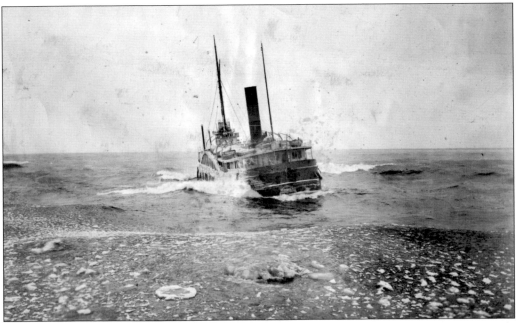

After she was freed, the *City of Duluth* was blown north to a new sandbar where she was severely pounded and damaged by the force of the waves. A rescue attempt by a tugboat failed to free the floundering ship. Passengers knew the end was near. Though the Life-Saving Station was closed down for the season, the crew quickly assembled and were able to rescue all 41 souls on board. (FMHS)

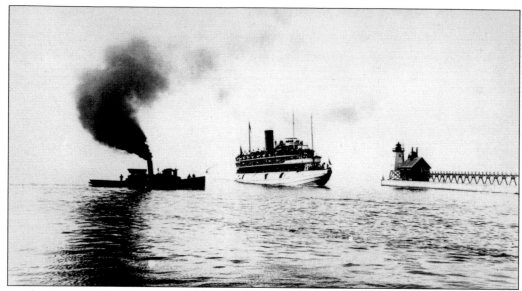

In the late 1800s, Alexander McDougall invented the Whaleback steamer. Its rounded deck and flat bottom gave it the appearance of a whale in the water and earned it the name Whaleback. This boat was specifically designed to handle the conditions of the Great Lakes by riding low in the water, allowing it to go through the waves instead of over them, and by offering wind resistance through its rounded shape. (FMHS)

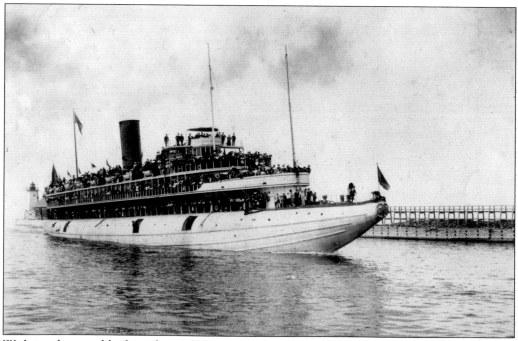

With its elongated body and rounded snout, sailors also called the Whaleback the Cigar Boat and the Pig Boat. In their 10 years of existence, over 40 Whalebacks plied the waters of the Great Lakes. Although some worried that they might roll over in the water, they proved to be as seaworthy as any other ship of their time. The *Christopher Columbus*, seen entering St. Joseph Harbor, was the only passenger ship in the fleet. (FMHS)

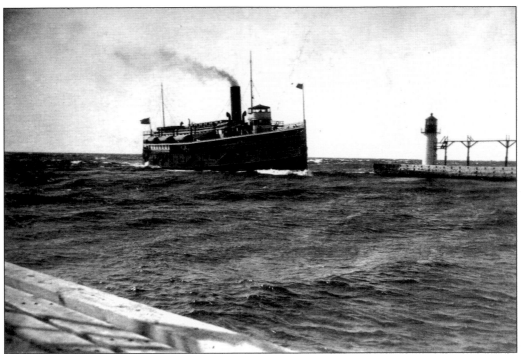

In 1898 an inner light was built on the north pier, creating a range light system that was helpful to ships entering the harbor. When a ship's captain could see the two lights of the pier lined up, one behind the other, he knew it was safe to make his turn for entry into the harbor. By 1907, the north pier had been extended and a new steel conical tower was placed on its end in order to maintain the range light system. (FMHS)

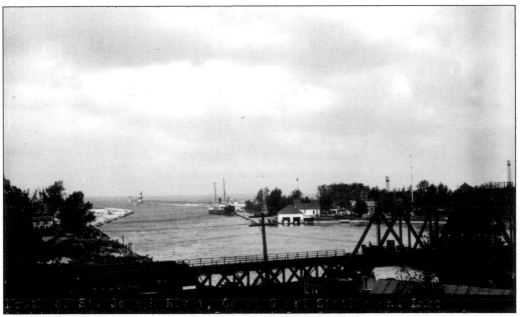

A harbor view from the early 1930s shows the Coast Guard building on the right and the completed range light system out near the lake. (State Archives of Michigan.)

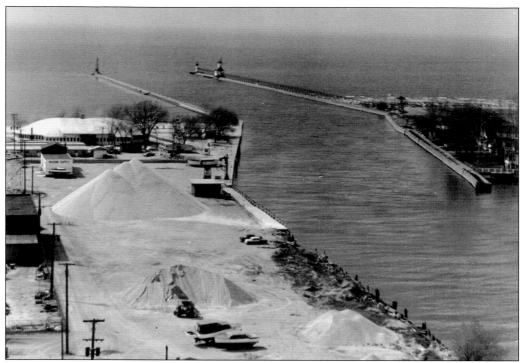

The extended north and south piers can be seen in this 1960 overview. Commercial use of the harbor was giving way to increased use by pleasure boaters. (FMHS)

Commissioned as the presidential yacht in the 1930s, the *Sequoia* made several trips to St. Joseph and other Lake Michigan ports in her 44 years of service in this capacity. Serving presidents Hoover through Ford, the *Sequoia* hosted many social and historic events on her decks. Reportedly, Hoover sought respite on her during the Depression, FDR and Winston Churchill were on board when they discussed plans for D-day, Nixon made plans to resign his presidency while on board, and Kennedy celebrated his 46th and last birthday party aboard the *Sequoia*. (FMHS)

Two

SOUTH HAVEN
PIER LIGHTS

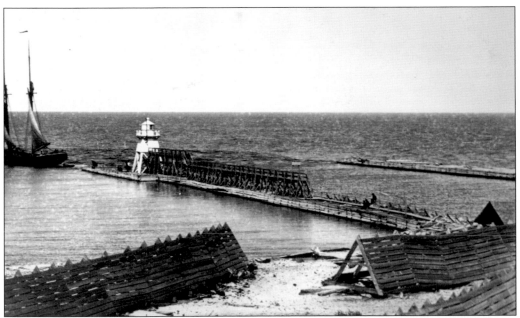

The early town of South Haven grew significantly as a result of the lumber industry. As lumbering flourished in the area in the mid-1800s, South Haven was established at the mouth of the Black River to support the resulting sawmills. In the years following, fishing, agriculture, and eventually tourism also contributed to the harbor's growth.

By the early 1860s, local businessmen had worked to improve the harbor by dredging the channel and constructing north and south piers. Near the end of the same decade the Army Corps of Engineers took control of the harbor and further widened and deepened the channel to make it more accessible to incoming vessels.

With the improvement of the harbor and the increase in shipping traffic, the need for a lighthouse to mark the harbor entrance soon became apparent. Congress responded to this need by appropriating funds for a beacon and a keeper's house in 1870. After some temporary construction delays, the beacon on the south pier was completed in 1872. The wooden tower had an open frame base topped by a storage room and an upper octagonal lantern room. (MMM)

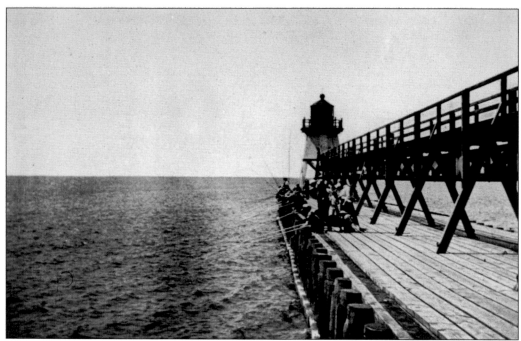

A wooden catwalk that ran up to the door of the light allowed the keeper to reach the beacon safely in foul weather. The wooden pier also drew fishing enthusiasts throughout the year. (MMM)

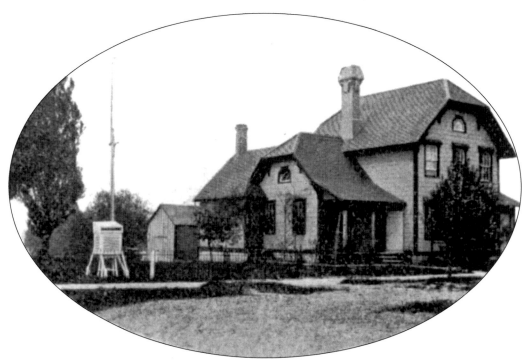

The light keeper's house was built in 1873 on a bluff overlooking the pier light. It contained a staircase that gave access to the south pier and the catwalk. This picture shows the house in the early 20th century after it has been remodeled several times. (MMM)

Captain James S. Donahue was the second keeper at the South Haven light and served in that capacity for 35 years. A decorated Civil War hero, captain Donahue won this appointment as a result of his military service. Although hampered by having lost a leg in the war, it is said that while he was light keeper he never missed a day on the job, even if he had to crawl out the pier to do it. (MMM)

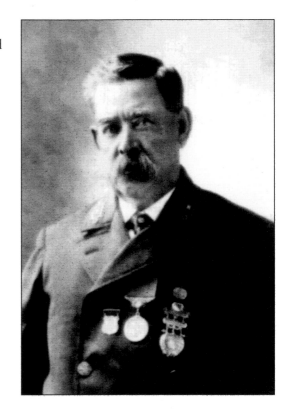

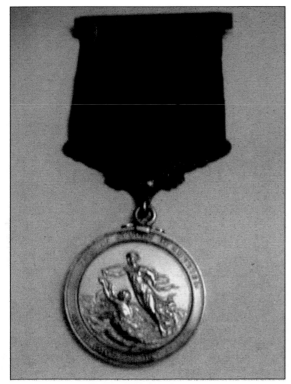

Captain Donahue was also a hero as a lighthouse keeper. He saved 17 souls from drowning during his years at the light, and received this medal in recognition of some of his heroic efforts. (MMM)

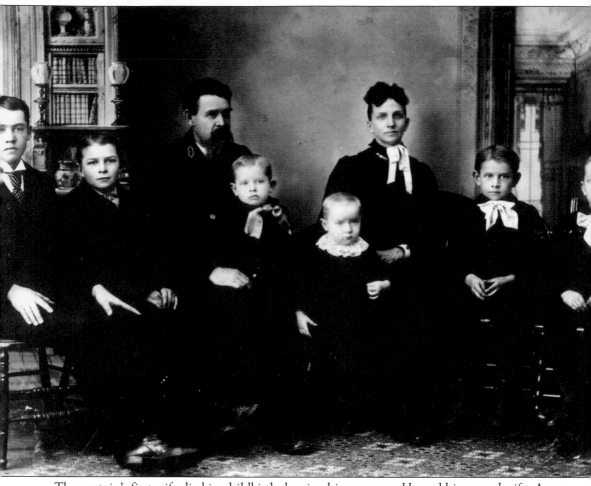

The captain's first wife died in childbirth, leaving him one son. He and his second wife, Anna, raised five more sons and one daughter. (MMM)

Members of the Donahue family pose for a picture in front of the keeper's house, c. 1893. Seated in the front row from left to right are sons John Bagley Donahue and Watson Bump Donahue, followed by wife, Anna, and dog, Fred. In the back row from the left are son John Markram, Captain Donahue, and (standing in the center) son Calvin Custer. Seated on the far right is son Walter Lane. (MMM)

Captain Donahue stands front and center at his Civil War reunion. The captain served in the 8th Michigan Infantry and participated in some of the most severe fighting of the Civil War. He was wounded on five separate occasions, the last time costing him his leg. (MMM)

Monday 22nd Snow and Cloudy wind high west it was
a toor gro .. wind went down. The lake was very rough
.. Staind in the west all day and night the
.. the Harbor full of Ice to the mouth I was
.. have had far years. I went to the Post Office
Tuesday 23rd Snow and Cloudy wind fresh South East at
5. atoor gro .. All the Fishtugs was braking Ice in the harbor
.. Steamsignal was Ordered down at Seven
.. I went to the Post Office at noon and again
.. I was gone from the Station back time one
Wednesday 24th Snow and Cloudy wind Gale west The wind
3. atoor gro .. the west and blowed a gale untill four P.M. the
.. up at four P.M. and the wind became moderate
.. from the west. no Signals. was Ordered for this
.. Order to Perch. a Five gallon can full of oil
.. Light Station. all day and night with the Exception
Thursday 25th Dry and and Clear wind gentle East. Weather
5. atoor gro. .. Sundow. and run it untill Eight p.m. the tugs came
.. at the Station all day and night The wind was
.. See I sent to the Post Office but didnet recive
Friday 26th Dry and Clear. wind fresh. East. the weather
7. Below gero .. far two hours in the Evening. and brout in the
.. light all the inhabitance report the Mercury down
.. to the Post Office in the Evening and to the Church
10. atoor gero 27th Rain and Cloudy wind fresh South East all day
Saturday .. the two Days Came in last and whisled and

Lighthouse keepers were required to keep meticulous daily logs. These included detailed weather reports and descriptions of lake activity, work done, visitors, and other occurrences. (MMM)

28

all day snowing and blowing. blustery and the wind
storm. Signal was up all day and night no Tugs out
at the Station. all day and night. one of the worst days we
at noon. didnot recive. any mail. from Head Quarters
day and in the East in the night nothing in sight on the lake
running. about all day keeping the Harbor from. freezing the
fire. P.M. no Storm to day but it Snowed hard all day and
in the Evening but didnot. recive any. goverment mail.
have. no. Tugs in the lake weather. too thick and See in the lake
was East in the morning. moderate untill ten am. then it went to
weather. was aweful blustery. and coald during the time it blowed
The Tugs was out but all come in as soon as the wind came
I went to the Post Office. at noon and. evening. I recived a
for the Signal lanterns. no other goverment mail I was at the
of gowing to the Post Office. being gone one hour from the Station
coald but Plesent. Two tugs out after dark I started the light at
in I Shut down. nothing. else. gowing. on in the Harbor I was
in the East all day and night. the Harbor is all Covred with glary
any goverment mail. the night was light and beautifull
coald but Plesant. all the Tugs was out I Started the light
Tugs. The Pumlee and Cue Ferrey. the lake Smooth the night
from 4. to 23. I was at the Station all day and night I went
Come at Eleven P.M. no Goverment mail recive to day
and night. Three tugs out I Started the light for two hours
I Shut down, the light. nothing Else in Sight on the lake
the rain froze as soon as it fell. I was at the Station all

Reading across pages 28 and 29, these pages of the captain's log from the 1880s document wind
and lake conditions and the work the tug boats were doing to keep the harbor waters from
freezing during the month of December. (MMM)

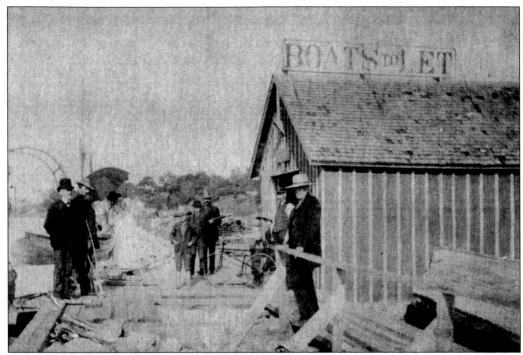

While he was the lighthouse keeper, Captain Donahue also ran a boat livery. He enjoyed the social interaction this job offered him. The captain is the man on the left of the picture leaning on the crutch. (MMM)

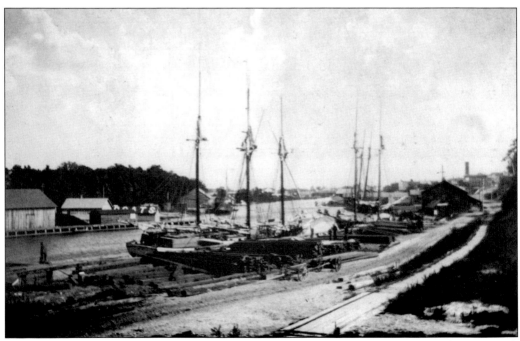

Lumber schooners and business establishments lined the embankment of the old harbor. (MMM)

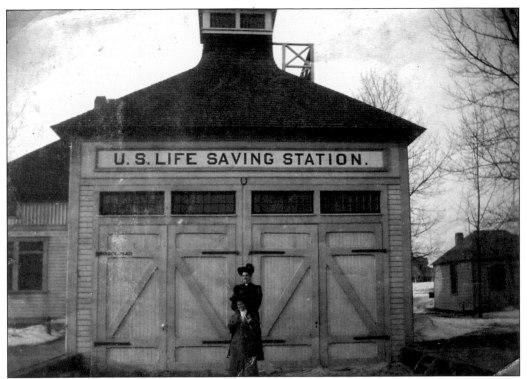

The U.S. Life-Saving Service Station was built on the north side of the river in 1887. The building was designed by architect Arthur Bibb, who liked to add a top-knot lookout tower on top of his stations. (J. Stieve Collection, courtesy of MMM.)

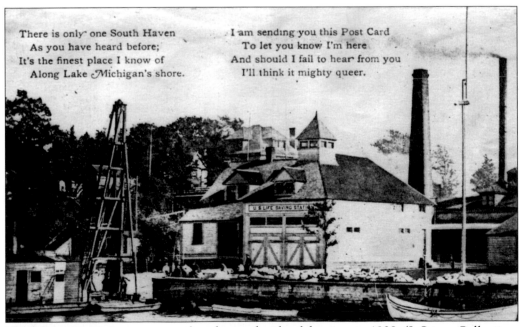

There is only one South Haven
 As you have heard before;
It's the finest place I know of
 Along Lake Michigan's shore.

I am sending you this Post Card
 To let you know I'm here
And should I fail to hear from you
 I'll think it mighty queer.

The life-saving station was moved to the south side of the river in 1908. (J. Stieve Collection, courtesy of MMM.)

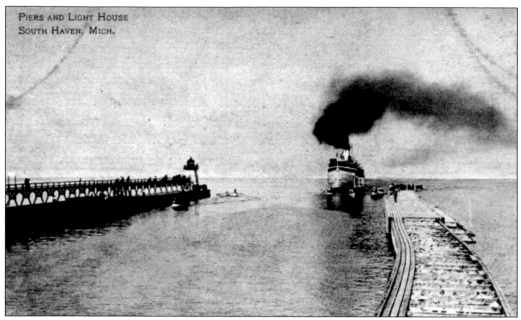

This early 1900s picture shows the north and south wooden piers and the original light on the south pier. (MMM)

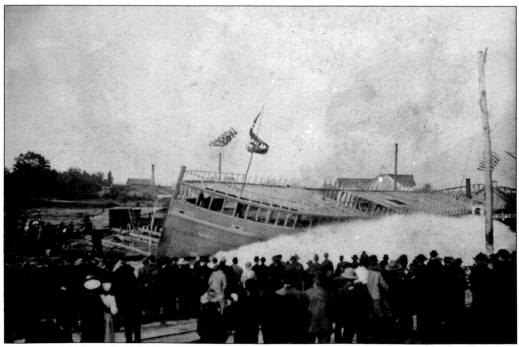

Between 1865 and 1900, many wooden sailing ships and steam-powered vessels were manufactured in South Haven. This picture shows the 1892 launching of one of these vessels, the *City of Kalamazoo*. (MMM)

Looking from the south toward the harbor, this view shows the outside wall of the pier painted with advertisements. The people in the foreground are climbing on old debris possibly washed ashore by the waves. (MMM)

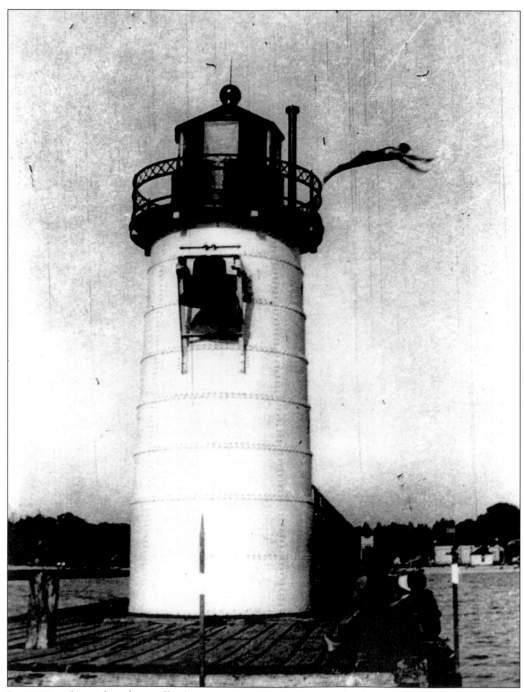

In 1903 a thirty-five-foot-tall white conical steel tower was built to replace the old wooden tower at the end of the south pier. The lantern and lens from the old tower were placed in the new tower. Ten years later a fog bell was added to the tower on the Lake Michigan side. An unidentified man dives from the new tower into Lake Michigan. (MMM)

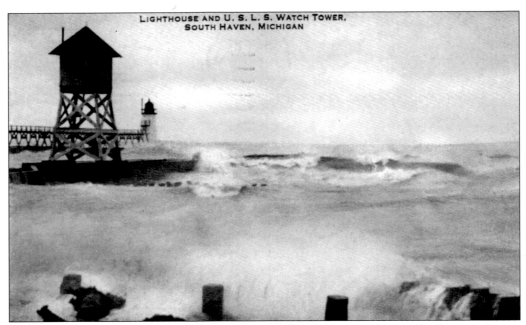

A postcard dated 1906 shows the new tower on the south pier along with the Life-Saving Station's lookout tower on the end of the north pier. (MMM)

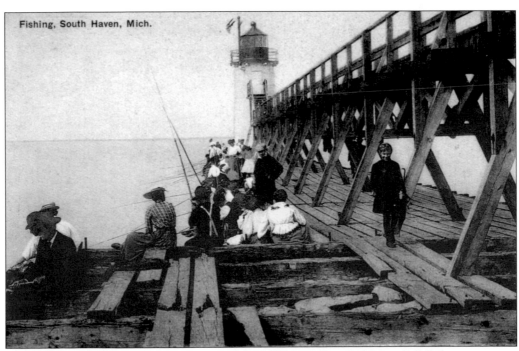

Men and women alike enjoyed fishing and socializing on the south pier. (MMM)

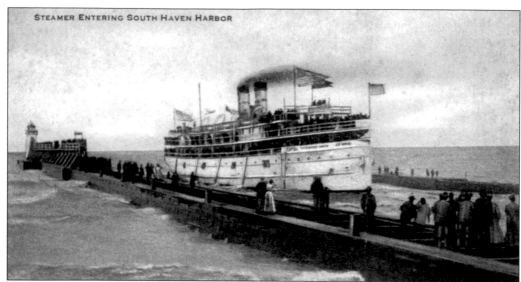

Tourism was heavy between South Haven and Chicago during the late 1800s and into the 1900s. Many passenger ships were seen entering and leaving the harbor during that era. (MMM)

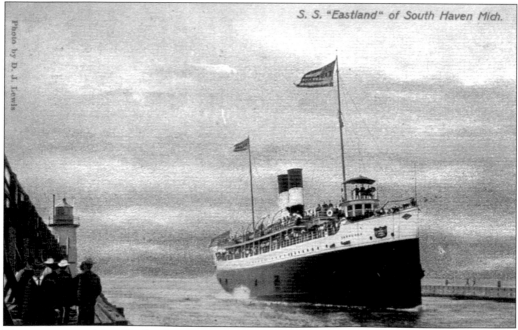

S. S. "Eastland" of South Haven Mich.

Photo by D. J. Lewis

The passenger ship, *Eastland*, seen entering the South Haven channel, made many trips between South Haven and Chicago during the heavy resort years. To cut down water resistance and improve her cruising speed, the *Eastland* was built to ride high in the water. This unique design proved to be successful and she soon became known as the "Speed Queen of the Lake." However, this design also caused numerous stability problems and the vessel often listed to one side or the other. On July 24, 1915 she was struck with disaster while docked in the Chicago Harbor. As hundreds of employees from Western Electric were boarding for a company picnic, the *Eastland* began listing starboard. Passengers continued to board and the boat rolled over, ultimately killing nearly 800 people. (MMM)

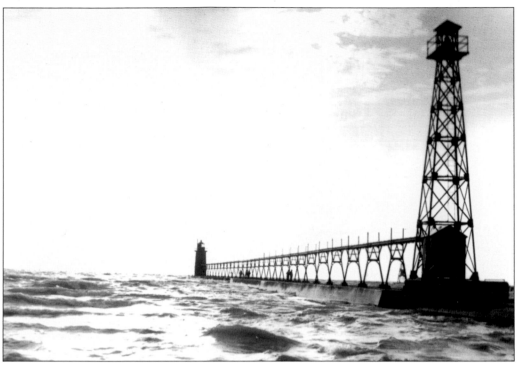

In 1916, a fifty-two-foot-tall steel skeletal tower was built behind the pierhead light to form a range light system to aid incoming vessels. (MMM)

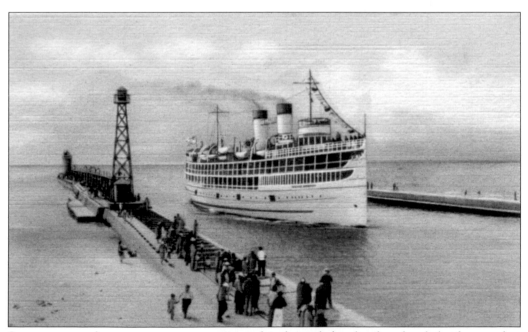

Spectators watch a passenger steamer enter the channel shortly after the skeletal tower has been added to the pier. (MMM)

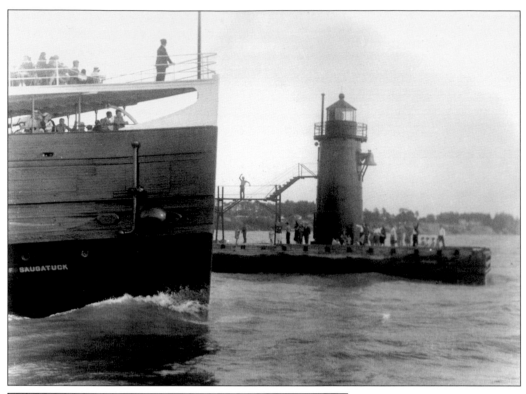

People on the dock hail passengers as the *City of Saugatuck* passes the tower on its way out of the channel. The original white tower has now been painted bright red. (MMM)

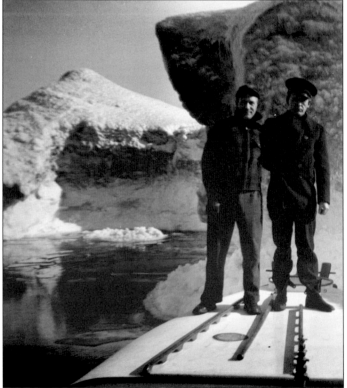

These men are standing in front of some ice caves that are common on Lake Michigan in the winter. As waves splash into the caves, water sometimes shoots up through a hole in the structure, producing an eruption, known as an ice volcano. (Roy S. McCrimmon Collection, courtesy of MMM.)

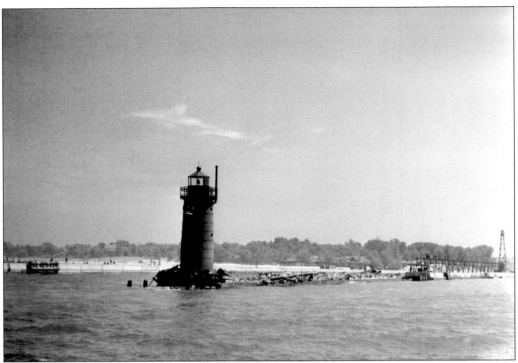

The pier went under major reconstruction in the late 1930s–1940s. The wooden pier was changed to concrete and the new catwalk was made of steel. (MMM)

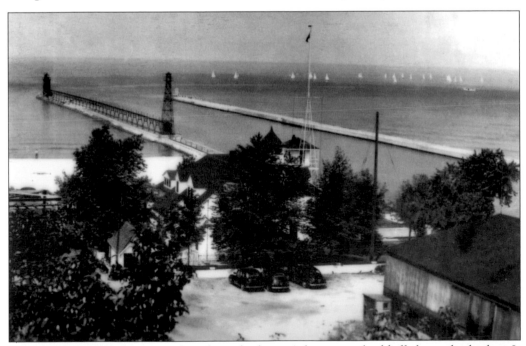

This view of the harbor was taken from the keeper's house on the bluff above the harbor. It looks out over the Black River and Lake Michigan. The white Coast Guard building is in the center of the picture. (MMM)

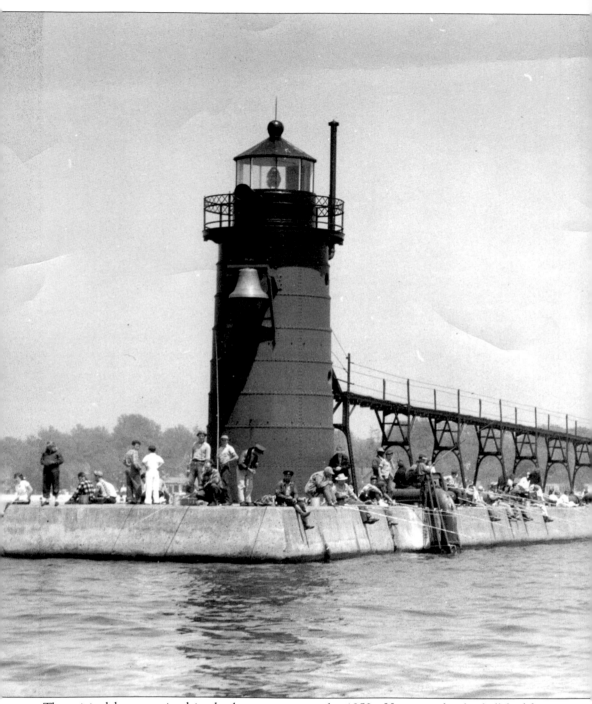

The original lens remained in the lantern room in the 1950s. However, the fog bell had been replaced by an air-powered fog horn and the bell was eventually removed from the tower. (MMM)

Three

KALAMAZOO
RIVER LIGHT

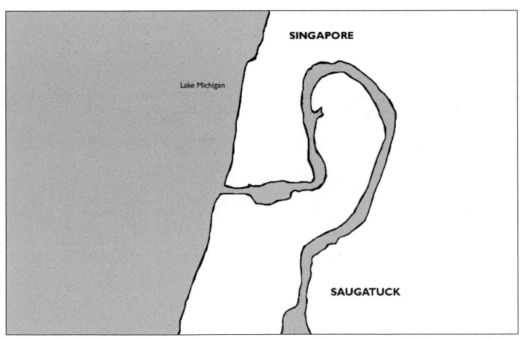

William G. Butler was the first white man to set up a homestead on the long, meandering Kalamazoo River and plat out the area that became known as Saugatuck. As more settlers arrived in the area, a sawmill began operating on the river between Saugatuck and the river mouth. The town of Singapore quickly sprang up to support this new mill.

As the lumbering industry steadily grew and more ships began using the harbor, local businessmen saw the need to mark the river entrance and erected a light at the mouth of the river. They soon realized that a more adequate light needed to be built and Congress granted funds to build a government lighthouse in 1837. The lighthouse was built and became operational in late 1839, making it one of the first lights on Lake Michigan.

Having been built near the river mouth and very close to shore, this light was constantly exposed to shifting sands and erosion. The natural mouth eventually veered to the north and the light was undercut by erosion and fell down in the late 1850s.

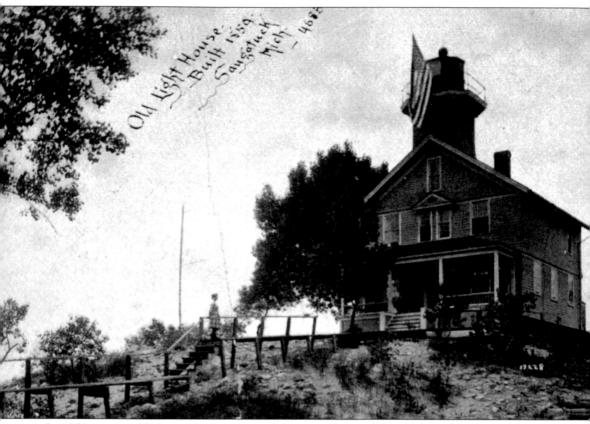

In 1859, a second light was built on a sand dune northeast of the old light. This was a two-story wooden structure with a square light tower on top. To help it withstand erosion, the house was built on a wood and pipe foundation. Large pieces of limestone were also laid on the dune to help keep the sand in place. (LJK)

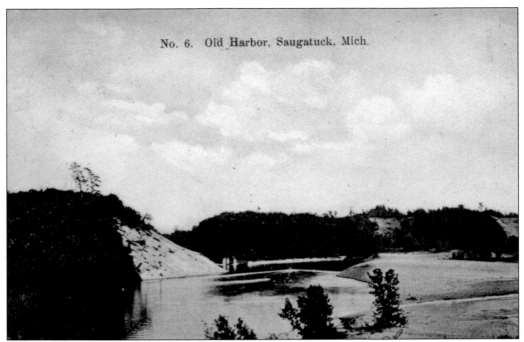

No. 6. Old Harbor, Saugatuck, Mich.

A view along the Kalamazoo River shows the sandy dunes along the river's edge. With so much sand in the area, erosion and shifting sands presented a continual hazard for ships trying to enter the harbor. (LJK)

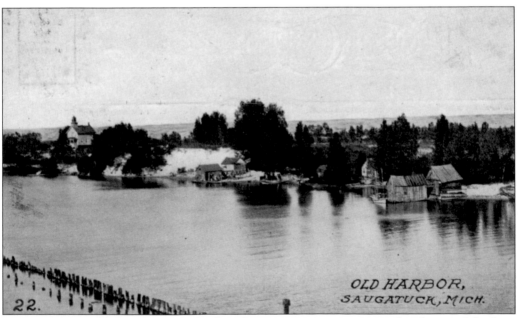

OLD HARBOR,
SAUGATUCK, MICH.

22.

As erosion continued to plague the harbor, Congress was again petitioned and granted funds to widen the river mouth and build piers on the north and south sides of the river. By 1876, these piers had been lengthened and a light was placed on a pole at the end of the south pier. The lighthouse keeper remained in the old lighthouse (upper left) and had to row across the river to maintain the new light. (LJK)

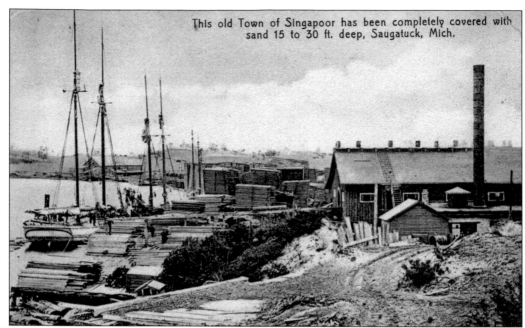

An 1869 picture shows the schooner *O.R. Johnson* in the foreground, loading lumber at a Singapore mill during the busy lumbering years. Six years later, as local lumber supplies had dwindled, the same schooner carried the mill and machinery off to a new location in northern Michigan. The buildings of this once-thriving community were taken down and Singapore quickly became a ghost town whose remaining foundations were buried beneath the blowing sand. (LJK)

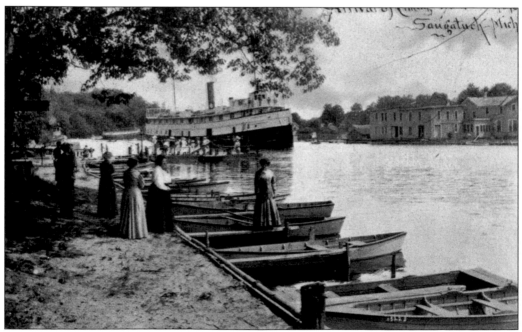

As lumbering died out in Singapore, tourism was on the rise in Saugatuck. People from Chicago liked to come to Saugatuck to avoid the summer heat of the city and enjoy the cool breezes on the east side of the lake. (LJK)

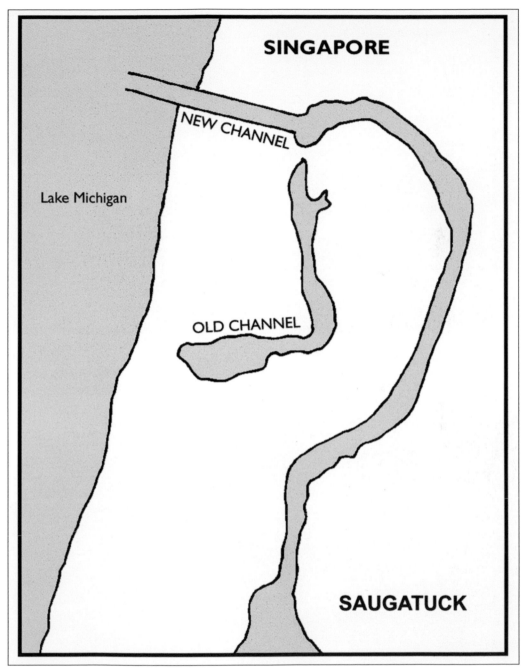

In the early 1900s, it was decided that a new river entrance to the north near Singapore was necessary. This entrance would be in a place less susceptible to erosion; it would eliminate a major bend in the river and it would cut off about a mile of river length.

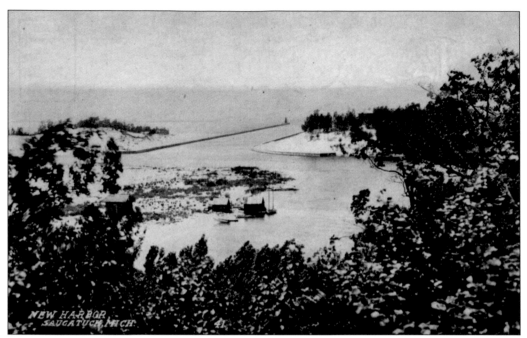

The new channel and piers were completed in 1906. (LJK)

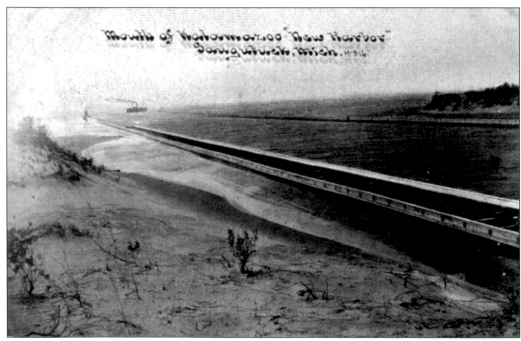

The new harbor, with its improved access to Saugatuck, was a welcome sight to incoming vessels. (LJK)

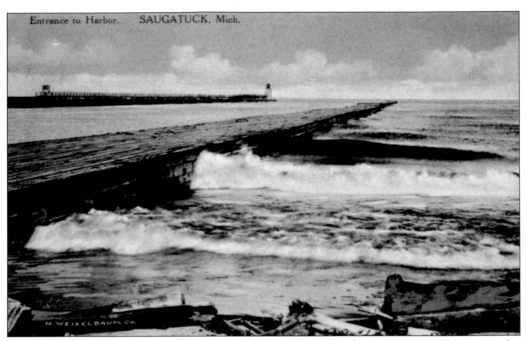

A square cast iron tower on a pedestal was added to the new south pier in 1909. Without regular dredging, sand had completely filled the old river entrance so that people could walk between the former piers. (LJK)

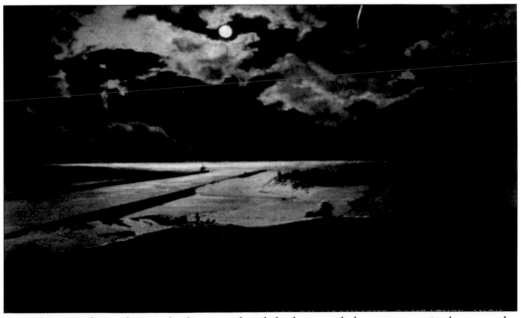

A similar view shows the new harbor at night while the moonlight casts an eerie glow over the water. (LJK)

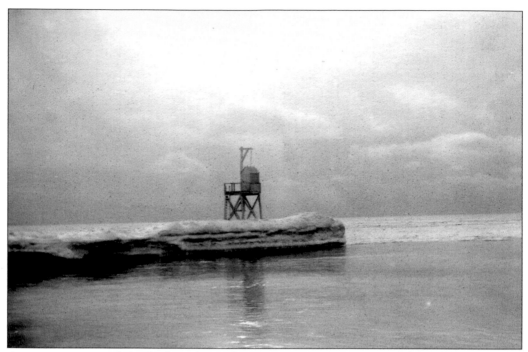

A winter picture of the harbor shows the pier encrusted in snow while the river remains unfrozen. (LJK)

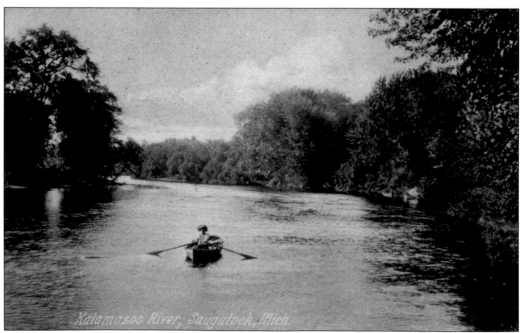

Privately-owned boats were used for fishing and recreation on the Kalamazoo River during most seasons of the year. This woman enjoys some quiet time in her rowboat. (LJK)

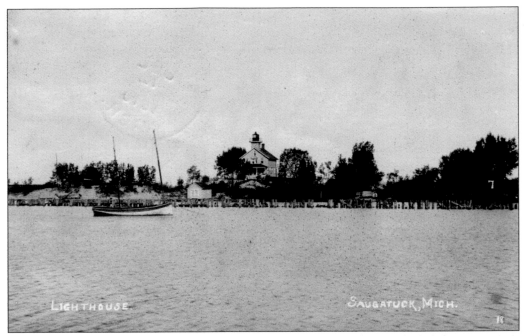

A view from across the river shows the wood pilings in the water in front of the lighthouse, c. 1910. The lighthouse was declared surplus when the light was added to the end of the south pier a year earlier. (LJK)

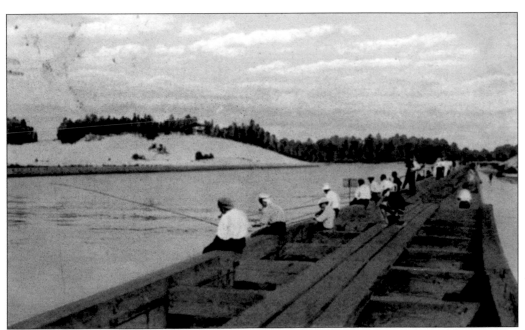

Steelhead Rainbow Trout were first introduced into the Lake Michigan watershed in 1880 via plantings in the Kalamazoo, Paw Paw, and Boyne Rivers. Many fishermen came to the Kalamazoo River piers during spring and fall runs, hoping to hook one of these magnificent fish.

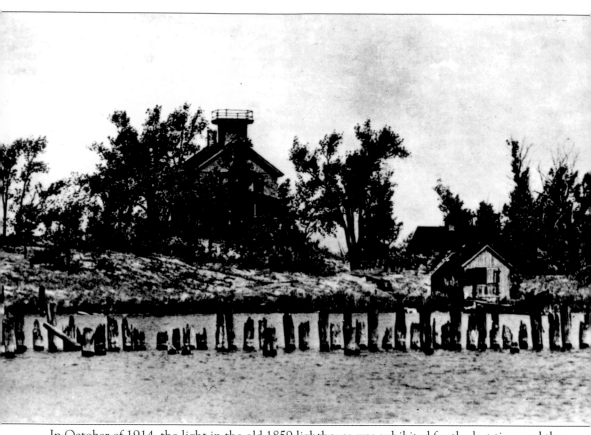

In October of 1914, the light in the old 1859 lighthouse was exhibited for the last time and the lantern was removed from the tower. The lighthouse was later sold to a private individual and used as a summer cottage. In 1956 the building was demolished by a tornado. (State Archives of Michigan.)

Four

HOLLAND
HARBOR LIGHT

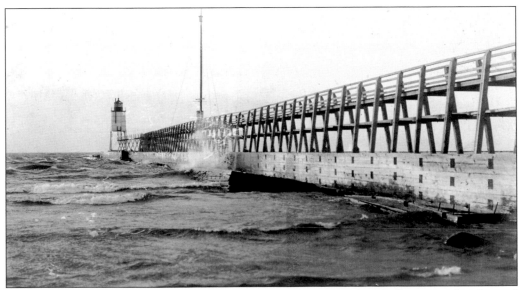

Lake Macatawa, formerly known as Black Lake, connects to Lake Michigan via the channel that separates Holland's Ottawa Beach on the north from Macatawa Park on the south.

Under the leadership of Rev. A.C. Van Raalte, the early Dutch immigrants realized the economic potential Black Lake could have if a channel connecting it to Lake Michigan could be cleared and maintained. Rev. Van Raalte made many pleas to the government for assistance, and in 1849, the U.S. Army Corps of Engineers responded by making a survey of the harbor. However, no further assistance was provided, so the locals decided to take the work upon themselves and managed to dig a shallow channel through to the lake. They continued their efforts until a violent winter storm caused so much damage that the whole project was abandoned.

The federal government was not actively involved in harbor improvements until the late 1860s. A small wooden lighthouse was erected in 1872, but the harbor itself was not essentially completed until the end of the century.

In the early 1900s, this light was built to replace the original light. It consisted of a square steel tower set on an open framework and was connected to the shore by a catwalk. (State Archives of Michigan.)

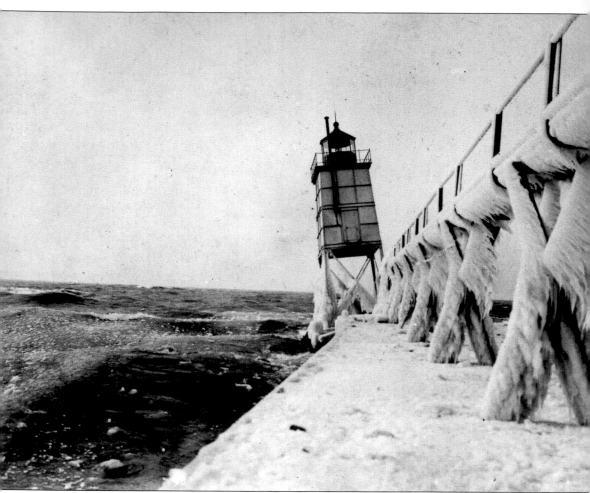

A sudden strong storm in December of 1904 tore away 50 feet of the south pier and left the new lighthouse tilted precariously over the water. Repairs were made to the pier and light the following spring, and the beacon was shining again by May. (From the Archives of the Holland Historical Trust.)

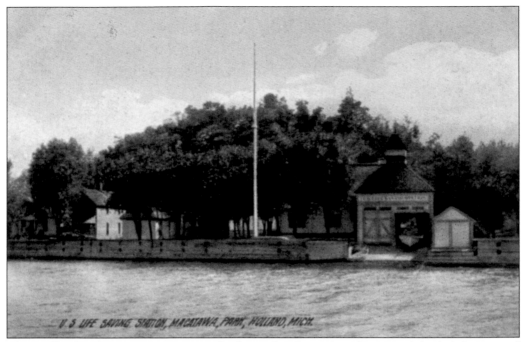

The Holland Life-Saving Station was built on the channel to the east of the lighthouse and became operational in 1886. The two-story structure had a lookout tower above the boat house which enabled the crew to keep watch for vessels in distress. (LJK)

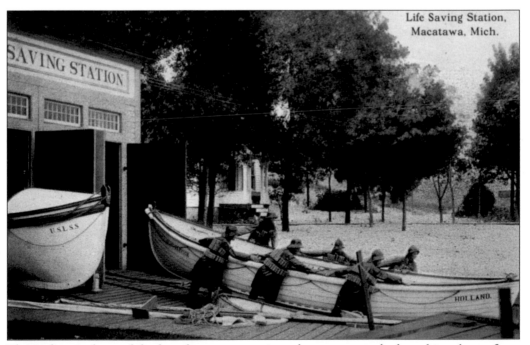

The incline in front of the boat house ran out into the water to make launching the surfboat easier. The crew spent much of their time practicing boat drills and also gave regular exhibitions to demonstrate their skills to the public. (LJK)

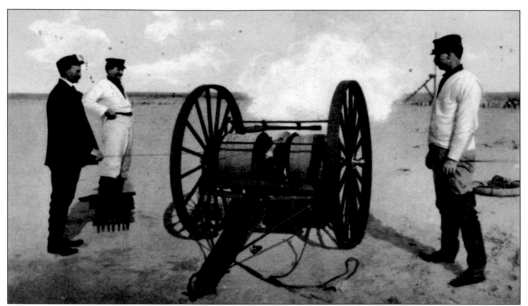

During a rescue attempt, life savers often shot a life line out to the floundering ship. When the line was secured, a breeches buoy was attached to it and pulled to the ship. Individuals sat in the breeches buoy and were pulled back to shore over the water one person at a time. (LJK)

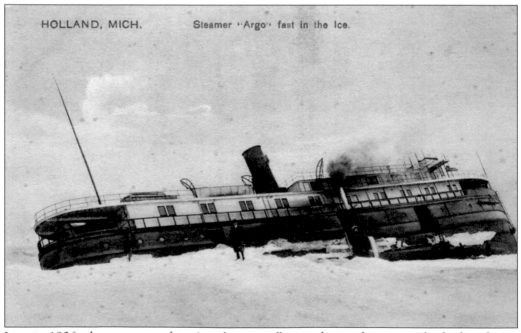

HOLLAND, MICH. Steamer "Argo" fast in the Ice.

Late in 1906, the passenger ship *Argo* hit a sandbar as she tried to enter the harbor during a strong gale. Through the skills and persistence of the life-saving crew, all passengers and crew and one horse were removed safely from her decks. A few months later—after several attempts—the ship was rescued and taken into port. (LJK)

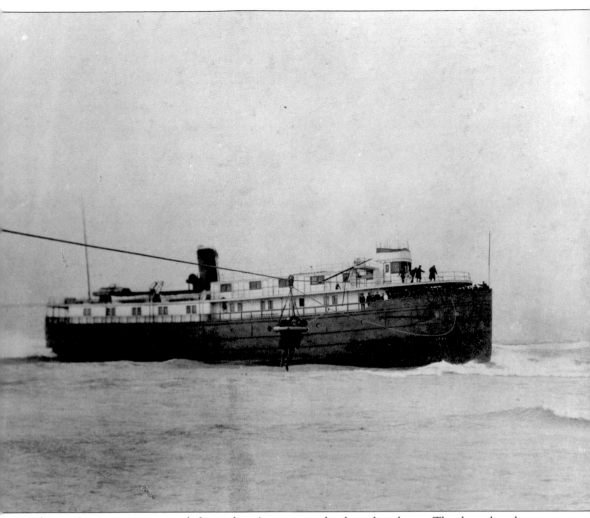

Juliette Canaan was rescued from the *Argo* using the breeches buoy. The breeches buoy was made of a life ring with canvas trousers sewn into it to make a kind of chair to sit in. Occasionally, as it did with Juliette's father, the line would slacken on the return trip and the passenger got dipped into the rough icy waters before landing safely on shore. (MMM)

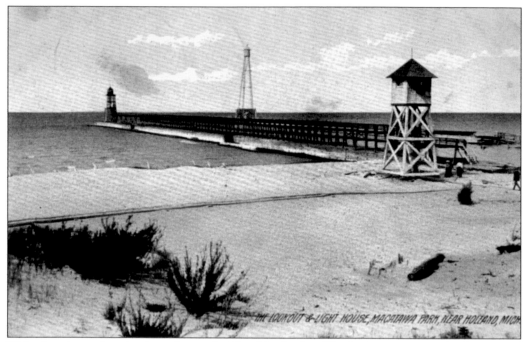

This view shows the pier from the south side of the harbor. The lookout tower in the foreground is on the beach at Macatawa Park, just across the channel from Holland. (LJK)

A picture taken from the same angle a few years later shows the addition of the fog signal building behind the light. (LJK)

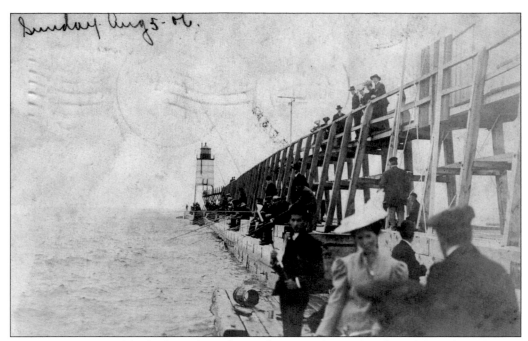

Common to many of the harbors along the southwest Michigan shoreline, fishing from the pier at Holland was a favorite pastime for many people. (LJK)

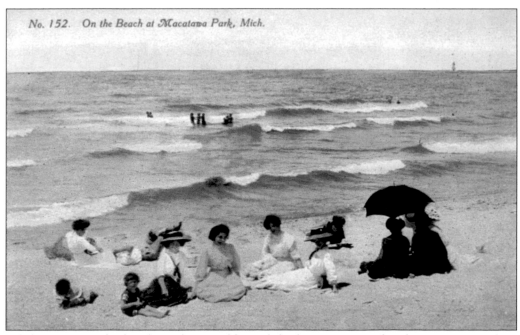

While sitting on the beach mothers could watch harbor activity as they kept an eye on their children who played in the water. (LJK)

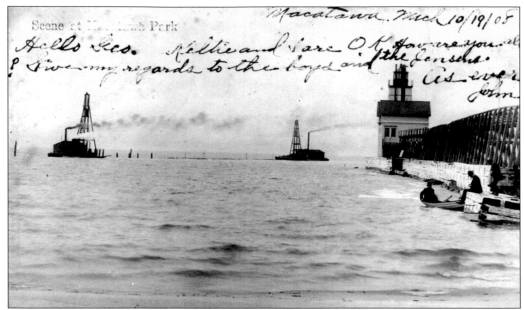

Remodeling of the harbor began after an appropriation of funds was received from Congress in 1906. The new breakwater was to be built according to the arrowhead design, which meant its finished shape resembled that of an arrowhead. (LJK)

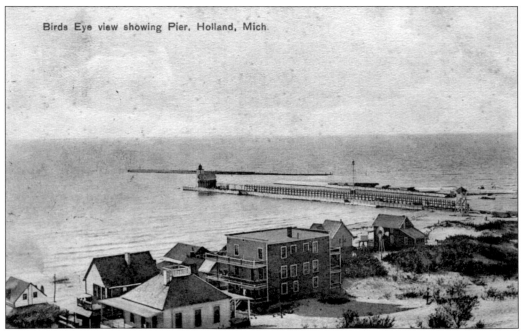

This overview of the shoreline from Macatawa Park shows that the north arm of the new breakwater has been completed but the south arm remains undone. (LJK)

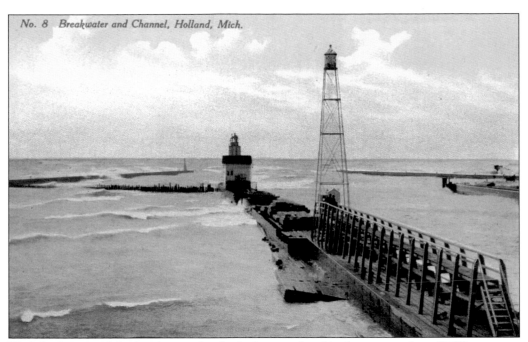

No. 8 Breakwater and Channel, Holland, Mich.

With both arms of the breakwater finished, the arrowhead harbor is complete. (LJK)

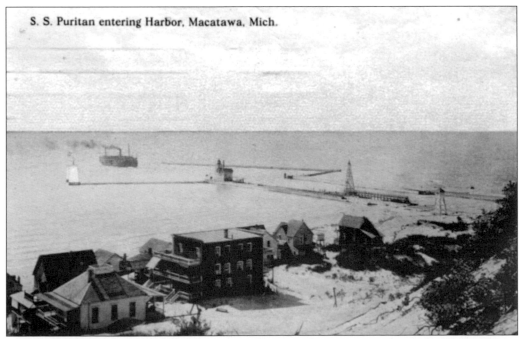

S. S. Puritan entering Harbor, Macatawa, Mich.

The arrowhead harbor was helpful to incoming ships because its wide opening offered easy entrance from the choppy waters of the Lake. The breakwaters calmed the water inside the harbor, which also facilitated vessels' entry into the narrow channel. (LJK)

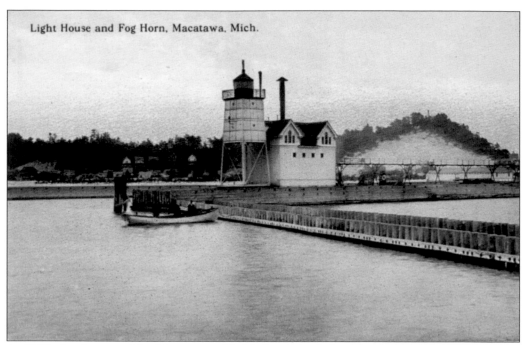

Light House and Fog Horn, Macatawa, Mich.

In 1907, the fog signal building was added behind the light. The gable-roofed building was sheathed in cast iron and painted a buff color. The first floor housed the coal bunker and the two marine boilers which were used to blow the signal. The second floor contained the watch rooms and a keeper's quarters. (LJK)

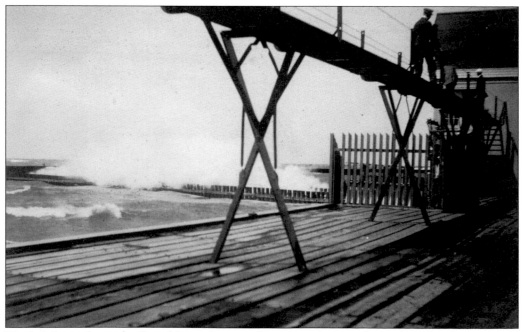

The lighthouse keeper walks safely on the catwalk over rough seas as he performs his duties. (LJK)

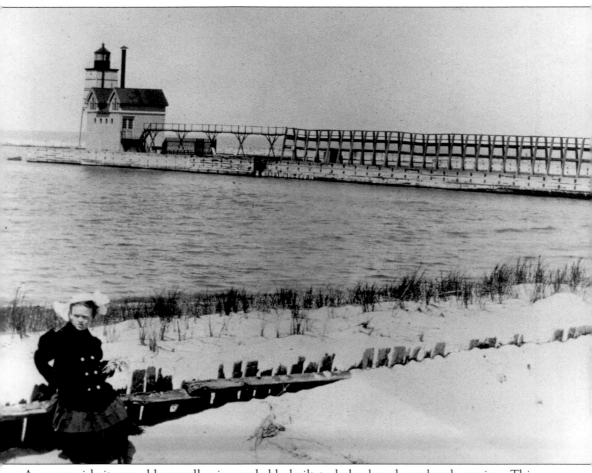

A young girl sits on old seawall ruins probably built to help slow down beach erosion. This picture taken at Macatawa Park provides a good view of the open frame tower standing in front of the fog signal building. (LJK)

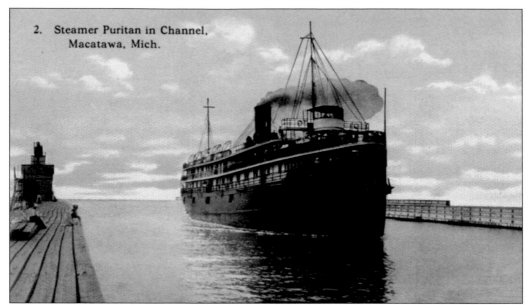

2. Steamer Puritan in Channel, Macatawa, Mich.

By the time harbor improvements had been completed, the peak lumbering years were over and the related economic opportunities had been missed. However, tourism had been growing since the 1880s and Holland Harbor became a favorite resort harbor. During the peak resort years, the Graham & Morton shipping line ran service twice a day from Chicago to handle the great number of passengers traveling to Holland and Macatawa Park. The *Puritan*, seen entering the harbor, was a passenger ship that made many trips from Chicago in the 1900s. (LJK)

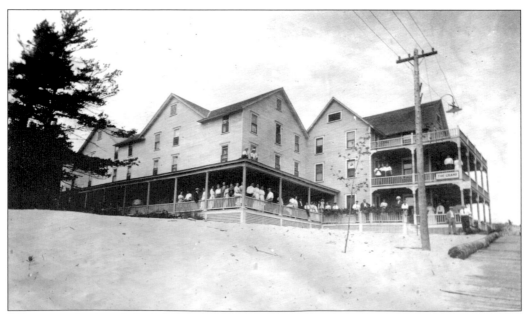

Resorts overlooking Lake Michigan and Lake Macatawa were popular tourist attractions for Holland and Macatawa Park in the early 1900s. Many times guests had to be turned away because all accommodations were filled. The popular Grand Hotel at Macatawa Park overlooked Lake Michigan. It was remodeled and enlarged several times in order to accommodate its many patrons. (LJK)

The Grand offered many amenities to attract guests, as seen in the local newspaper ads. (LJK)

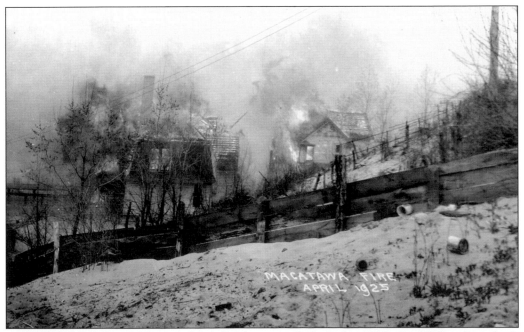

At least three major fires raged through Macatawa Park in the 1920s. In 1925, a fire which started on the roof of the Grand destroyed the hotel along with many other buildings before it was finally extinguished. (LJK)

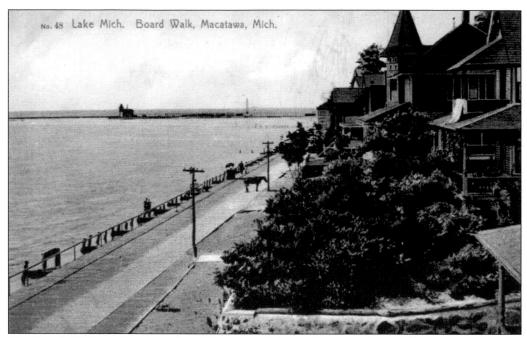

The Lake Michigan shoreline along Macatawa Park was dotted with many fine cottages. One of these cottages, "The Sign of the Goose," was owned by L. Frank Baum, author of *Father Goose* and *The Wonderful Wizard of Oz*. Frank was active in the community and did some writing while summering here. (LJK)

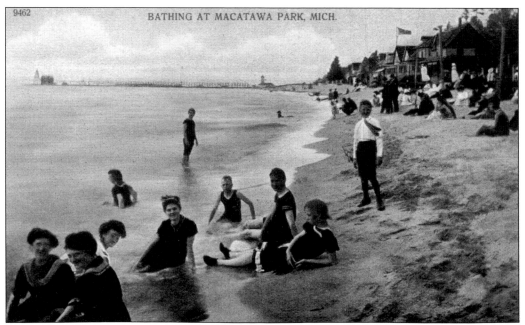

In the 1920s Macatawa Park was a favorite place to go to enjoy bathing in the lake and gazing at the beautiful water and the lighthouse. (LJK)

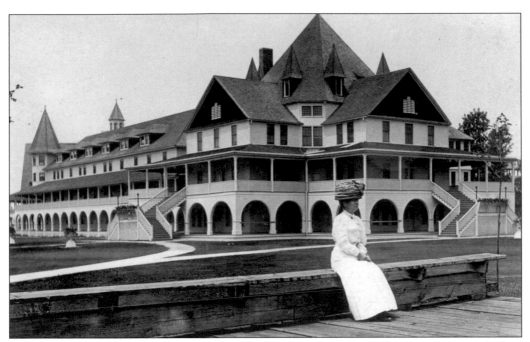

Across the channel, the stately Ottawa Beach Hotel was a popular Holland resort. It overlooked Lake Macatawa near the channel entrance. Unfortunately, this hotel also met its demise as the result of a fire. (LJK)

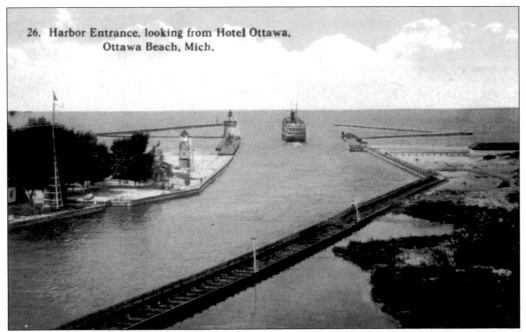

26. Harbor Entrance, looking from Hotel Ottawa, Ottawa Beach, Mich.

This view of the channel is looking out toward Lake Michigan from the Ottawa Beach Hotel. On the left behind the lighthouse is the lookout tower and the Coast Guard Station, which is nestled in the trees near the flagpole. (LJK)

Harbor Ottawa Beach & Macatawa River

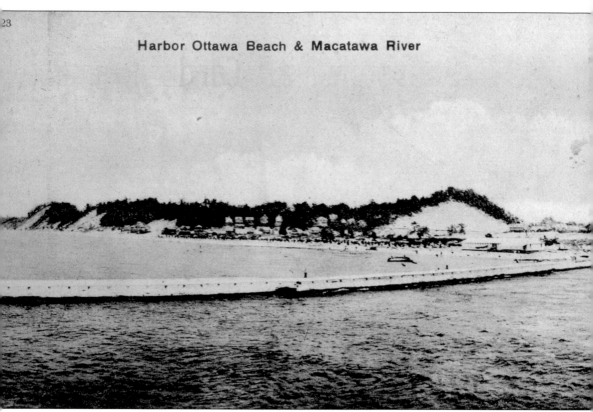

Looking down the channel toward Lake Macatawa, this picture gives a good view of Lake Macatawa Park on the right and Ottawa Beach on the left. The piers on both sides were

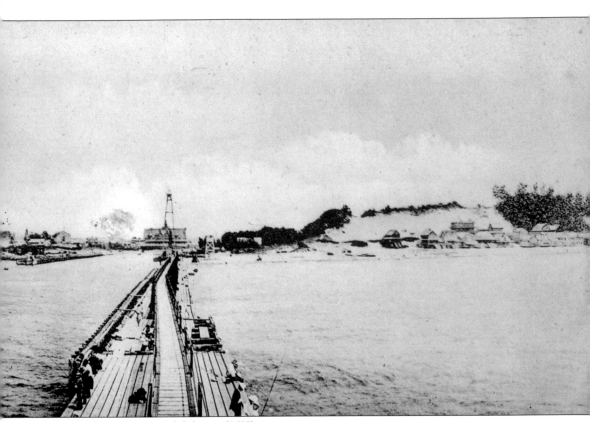

accessible for walking and fishing. (LJK)

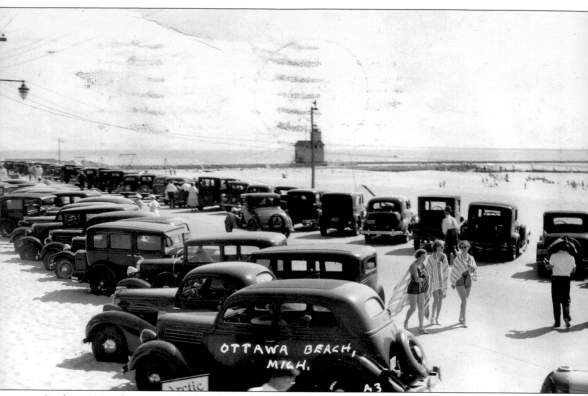

In the 1930s, driving to the beach for the day was a fun adventure. On hazy or foggy days, beach goers could listen to the droning of the fog horn as it sent out its warnings. In 1936 the free-standing steel tower was removed and a new tower was placed on top of the fog signal building. The lantern room and the light from the old tower were placed in the new tower. (LJK)

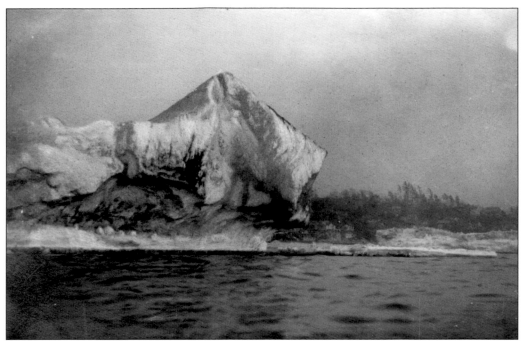

Winter storms in the early 20th century seemed fiercer than storms today. This iceberg stood over 30 feet high. Notice how short the building on the right looks in comparison to it. Icebergs along the shoreline were somewhat helpful in slowing down winter beach erosion. (LJK)

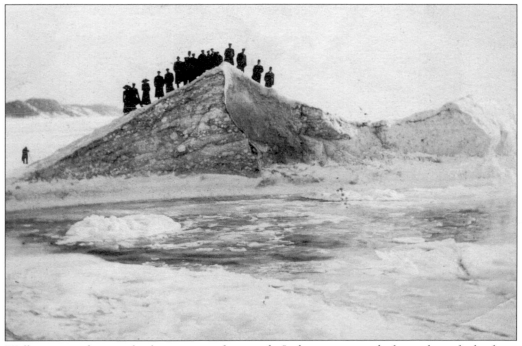

Walking on icebergs is fun but it is not always safe. Icebergs move and often split with the force of the incoming waves, exposing open water beneath. (LJK)

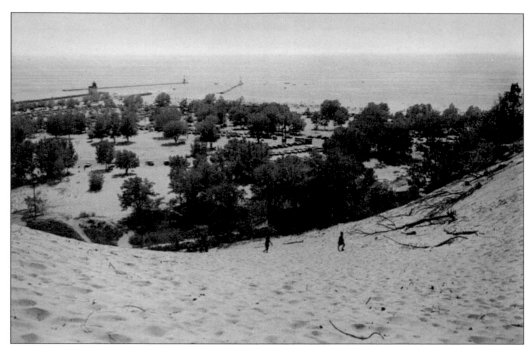

With its miles of white sand beaches, the Lake Michigan shoreline was a favorite place for sand dune climbing as well as sunbathing and shooting photos in the 1950s. (LJK)

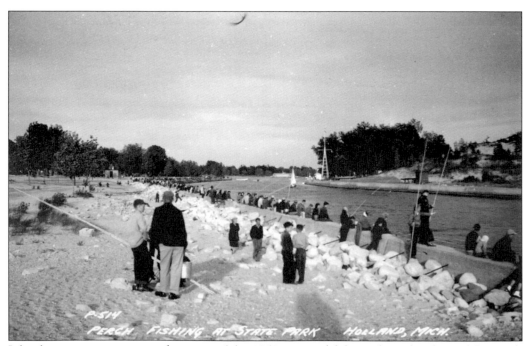

Like their ancestors, men and women of the 1950s enjoyed fishing along the channel for perch and trout. (LJK)

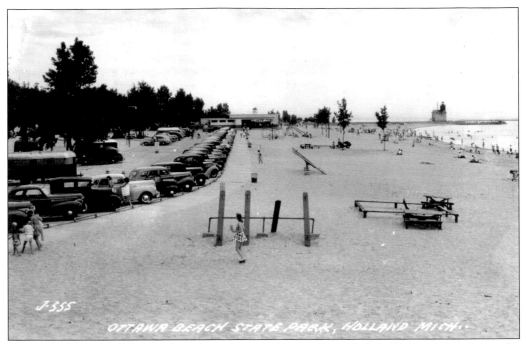

This c. 1950 view of the beach and pavilion at Ottawa State Park in Holland also shows the lighthouse shortly before it was painted a new color. (LJK)

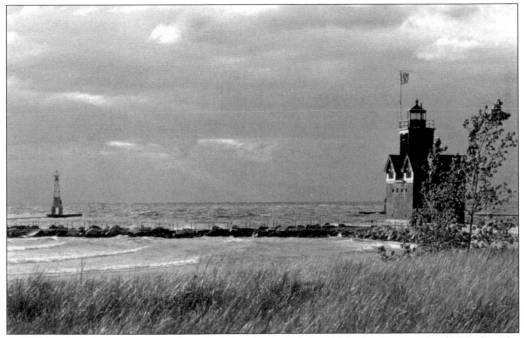

In 1956, the lighthouse was painted bright red in keeping with the Coast Guard mandate for red-right-returning. This mandate required that markers on the starboard side, as one returns from a larger body of water, are to be red in color. As a result of its new paint job, the Holland Harbor Light has affectionately become known as "Big Red." (LJK)

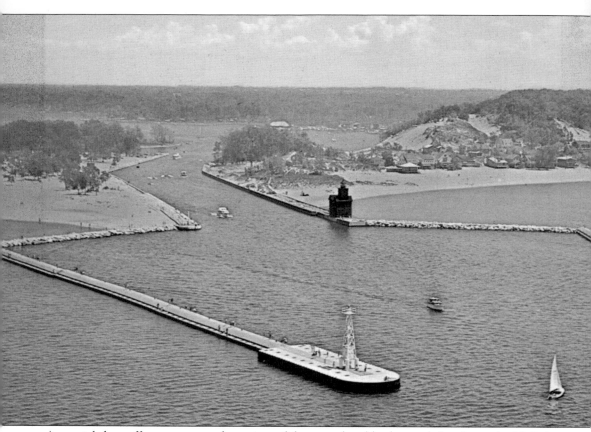

An aerial shot offers a more modern view of the arrowhead harbor and the channel with Lake Macatawa in the background. (LJK)

Five

THE GRAND HAVEN LIGHTS

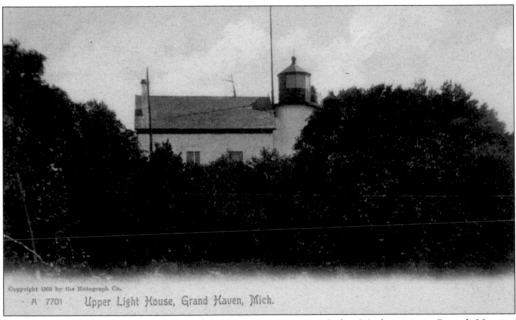

Copyright 1905 by the Rotograph Co.

· A 7701 Upper Light House, Grand Haven, Mich.

Michigan's largest river, the Grand River, empties into Lake Michigan at Grand Haven, forming a wide and deep natural harbor that can accommodate large ships. For this reason it has always been one of the busiest ports on the lake and one which Congress has had a strong interest in maintaining. In 1852 Congress appropriated funds for harbor improvements, and several years later revetment construction began on the south side of the river. In the years following, improvements were also made to the north side of the river to better accommodate vessels carrying lumber, grains, and eventually tourists.

The first lighthouse in Grand Haven, called the Grand River Light, was built in 1839 on a piece of land known as "Lighthouse Acre." This light was built at the mouth of the river where it was exposed to the severe weather of the lake, and it was ultimately destroyed by a violent storm in December of 1852. The structure pictured here was built on a bluff above the first light in 1855. This house was a one and one-half story solid stone structure complete with a tower and a light on its south end. (MMM)

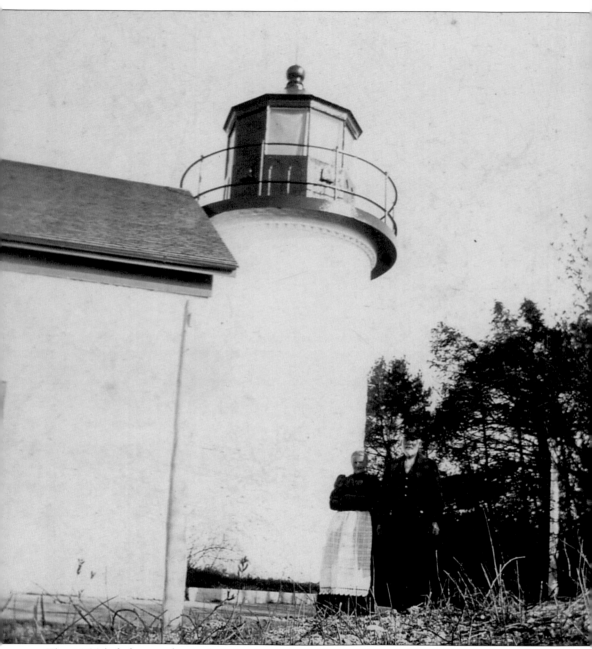

The 1855 lighthouse also included a keeper's residence. Captain Frank Frega, who served as keeper from 1900 to 1911, poses with his wife by the light tower. (TCHM)

A fog signal building was added to the end of the south pier in 1875. (TCHM)

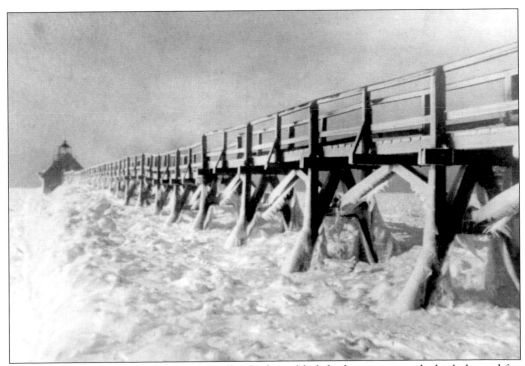

The old pier had a raised wooden catwalk which enabled the keeper to reach the light and fog building when the pier was covered with ice. (TCHM)

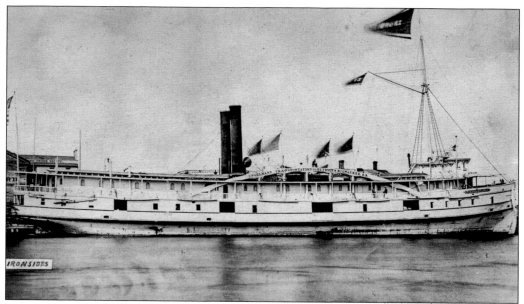

Before the Life-Saving Service came to Grand Haven, a volunteer life-saving crew was established to help perform rescues. The *Ironsides*, above, was trying to enter port during a strong gale in 1873. After two failed attempts, the captain decided to go into deeper water and wait out the storm. However, the boat took on water and began to sink, so the passengers were evacuated into life boats. When three of the life boats capsized and their occupants were thrown into the lake, the volunteer life-saving crew and some local townspeople formed a human chain out into the water and saved many of the passengers from certain death. (TCHM)

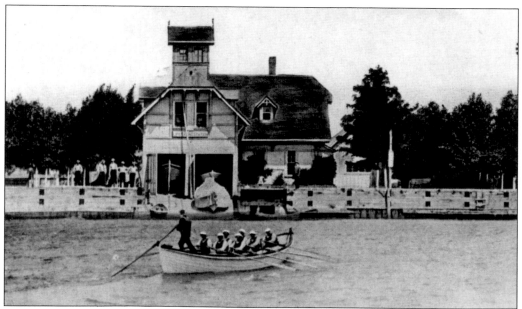

The U.S. Life-Saving Station in Grand Haven opened May 1, 1877. It was built on the north side of the river near the harbor entrance. This was the beginning of a long-standing relationship that still exists today between Grand Haven and the Life-Saving Service, which later became the U.S. Coast Guard. (State Archives of Michigan.)

This 1880s view of the harbor shows the Life-Saving Station on the right side of the river and the light on the left. (TCHM)

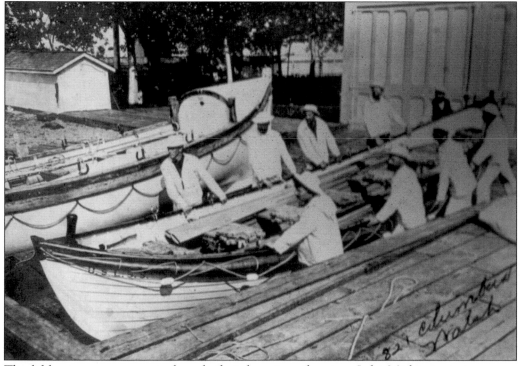

The lifeboat crew prepares to launch their boat into the river. Lake Michigan stations were often built along harbors or rivers instead of on the open waters of the Lake, which made their boat launching task easier. Many stations had inclines or ramps that allowed the men to slide their boats straight from the boat house into the water. (TCHM)

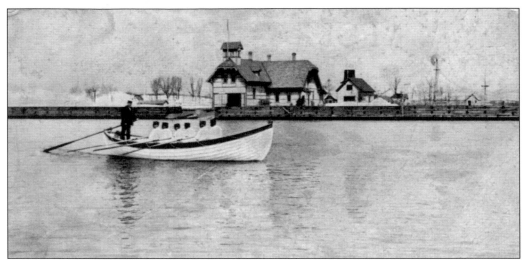

Members of the Life-Saving crew spent much of their time practicing rescue drills so they would always be ready for an emergency. (TCHM)

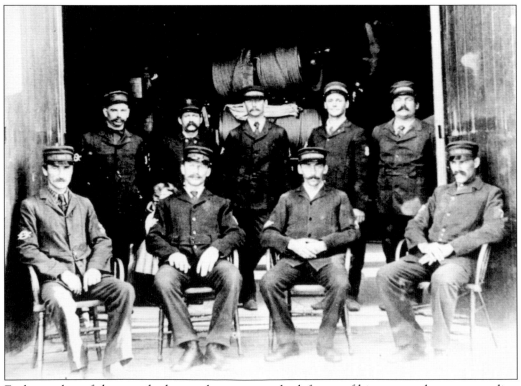

Each member of the crew had a number, seen on the left arm of his coat, and a corresponding duty. Number one was the highest rank and was given to the man with the greatest skill and experience. Seeking higher numbers often provoked competition among the men. In the front row from left to right are Charles Robinson, Jacob VanWeelden, Charles Peterson, and Herman Castle. In the back row are Peter Deneau, John Lysaght, John Walsh, Frank Vogel, and William Walker. Captain John Lysaght was the Life-Saving Station's keeper for 22 years, the longest of any at Grand Haven. (TCHM)

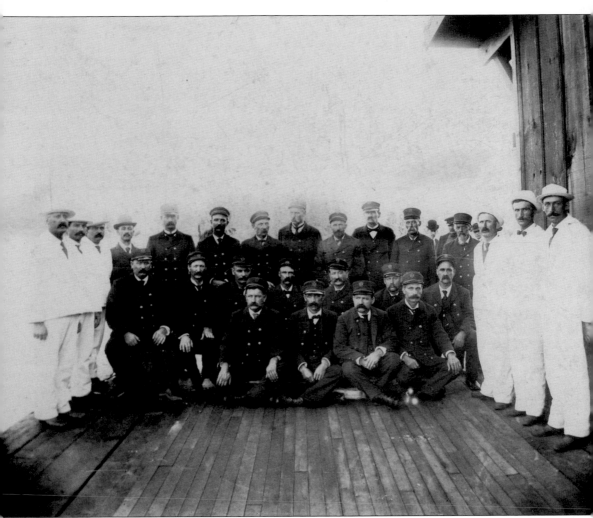

The brave members of the 1905 Life-Saving crew pose for a picture at the station. Experiments with motorized lifeboats were performed in the late 19th century to try to improve speed and power during rescues. The 1905 Grand Haven crew did not yet have a motor boat, so they sometimes called on local tugboats to assist them in emergencies.

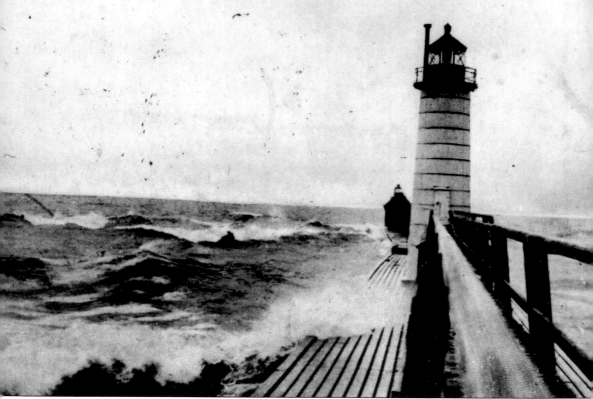

By 1905, the south pier had been extended several times and the fog signal building was moved out to the new end. A new conical steel tower was placed behind the fog signal building. The light of the fog signal building and the new tower light together formed range lights. (State Archives of Michigan.)

A walk on the pier often involved posing for a picture or two near the new tower. (TCHM)

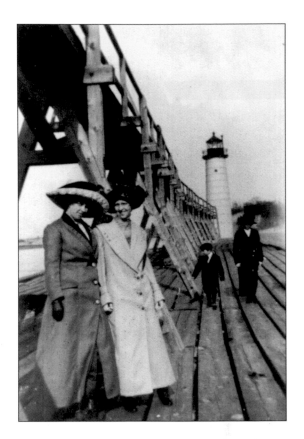

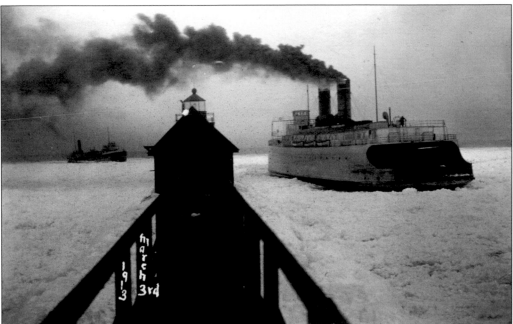

The Grand Haven car ferry struggles to get through the icy waters of the harbor late in the winter of 1913. (TCHM)

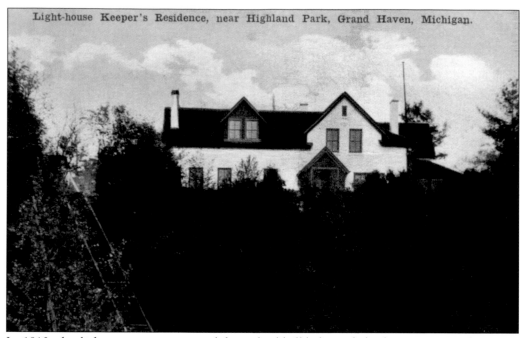

Light-house Keeper's Residence, near Highland Park, Grand Haven, Michigan.

In 1910, the light tower was removed from the bluff light and the house went under major reconstruction. It remained the residence for keepers and their families until 1939. (TCHM)

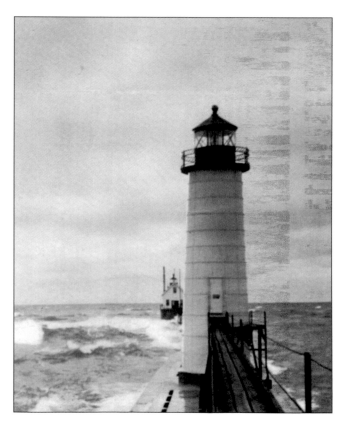

In 1916, work began to change the old wooden walkways of the piers to concrete. This was completed in 1922. Both structures were later painted red. (TCHM)

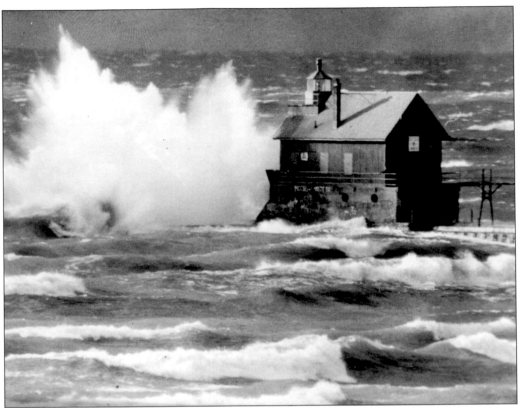

In 1922 the fog signal building was sheathed with corrugated steel to help prevent corrosion. (TCHM)

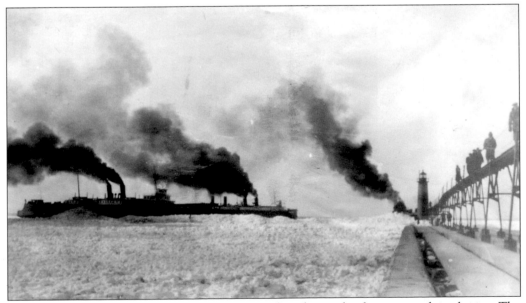

The harbor remained active in the winter even though vessels often got stuck in the ice. The ferries pictured above are trying to make it into port during the winter of 1928. (TCHM)

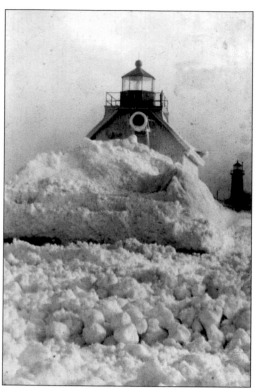

Looking in from Lake Michigan, the fog signal building is mostly covered in ice. The lake side of this building is V-shaped like the bow of a ship to help protect it from the waves and ice that crash into it. (TCHM)

Covered in ice, the pier takes on a different kind of beauty during the winter of 1940. (TCHM)

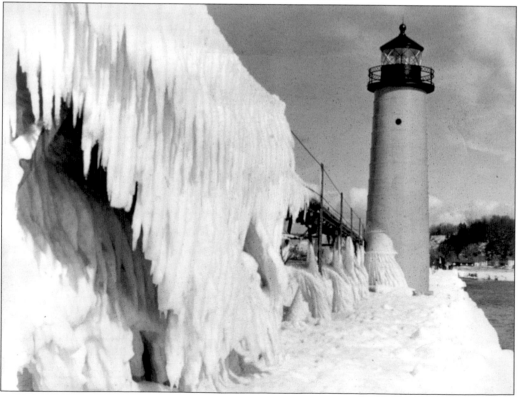

Six

MUSKEGON LIGHTS

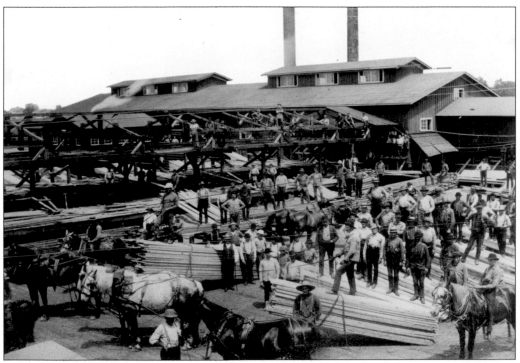

The early town of Muskegon was surrounded by lush hardwood forests and held direct access to Lake Michigan via the Muskegon River and Muskegon Lake. These combined resources made Muskegon a natural lumbering town, with its first sawmill becoming operational in 1837. The lumber business did not boom, however, until after the Civil War when people began moving westward and needed lumber for construction. By 1860 there were 13 mills in Muskegon, and by the 1880s the Muskegon/White Lake area was known as the "Lumber Queen of the World."

The John Torrent mill was one of the key mills operating during the peak lumbering years. After his first mill was destroyed by a fire in 1873, John built a new mill on the same sight and later expanded and improved it. The new mill, pictured above, became known as "The Big Mill." (MCM)

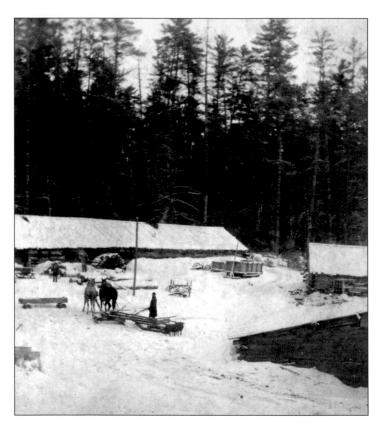

Trees were generally felled during the winter and removed from the forest by horse-drawn sleds. They were then placed in stacks on the riverbanks and left until the following spring. Many local farmers became temporary lumberjacks during their off-season to help with the cutting process. (MCM)

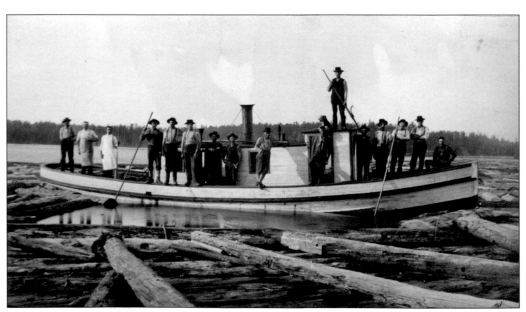

When spring arrived, the stacks of logs were released and rolled down to the river. The higher spring waters of the river made it possible for the logs to float down the river to Muskegon Lake, where the lumberjacks would guide them to the mills. (MCM)

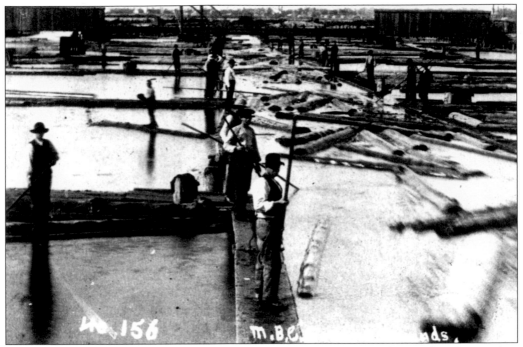

Lumbermen used marks or brands placed on the end of each log to identify their logs and to help prevent log rustling. At the mouth of the river, the logs were sorted by these brands and placed in pens until they were towed in rafts to the proper mills. (MCM)

After the lumber was milled, it was stacked and seasoned before it was loaded on schooners for shipment. (MCM)

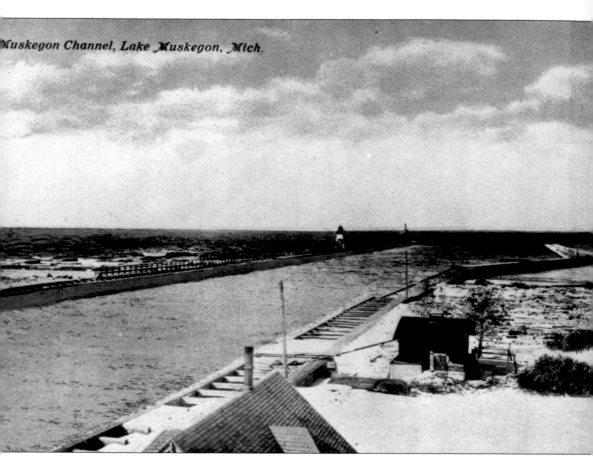

Muskegon Channel, Lake Muskegon, Mich.

The early channel in Muskegon was undefined. Shifting sands changed the outlet and narrow meandering waters made it difficult to navigate. In 1863, local businessmen formed the Muskegon Harbor Company for the purpose of improving the channel. They provided $40,000 to straighten and deepen the channel, and also built a slab pier into Lake Michigan. Four years later, Congress appropriated funds to further improve the channel and place a light at the end of the pier. By 1898 the south pier had been extended and a fog horn was added to its end. (MCM)

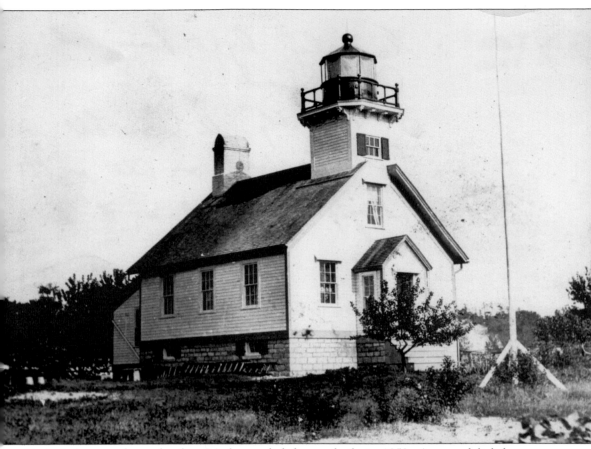

Little is known about the first Muskegon lighthouse, built in 1852. A second lighthouse, pictured above, was built on shore in 1870. It was a one-story wood-frame building with a square tower and light attached to its roof. (MCM)

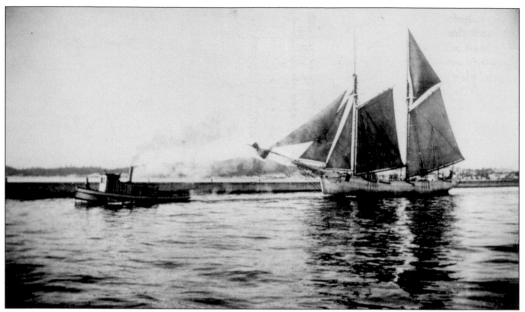

During the peak lumbering years it was not uncommon to see over 20 sailing vessels entering or leaving the harbor in a 90 minute time period. One of the favorites was the schooner *Lyman M. Davis*. The *Lyman Davis* was built in Muskegon and was said to be the fastest sailing ship on the Great Lakes. (MCM)

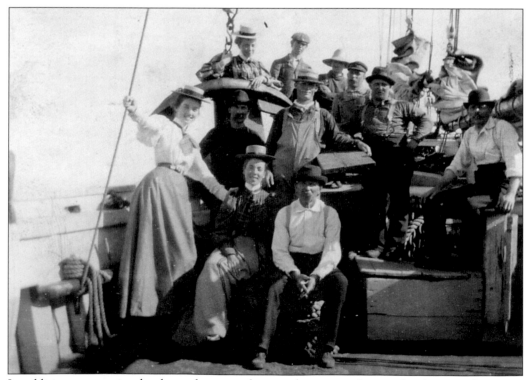

In addition to carrying lumber, schooners also ran short excursions to local areas of interest. Above, passengers experience sailing on the *Lyman M. Davis* during an excursion. (MCM)

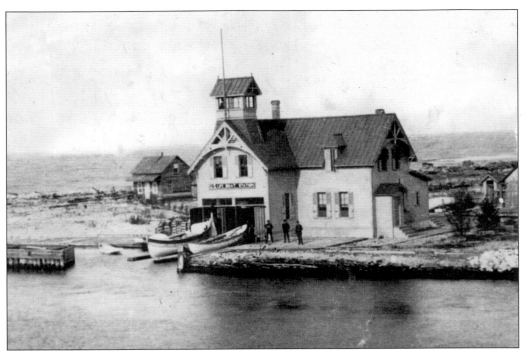

Lighthouse keepers were often called upon to aid in rescuing victims of floundering ships. At times they worked with the Life-Saving Service in these rescue attempts. In 1880, a Life Boat Station opened on the north side of the Muskegon channel. True to their motto, "You have to go out but you don't have to come back," these brave men risked their lives every time they performed a rescue. (MCM)

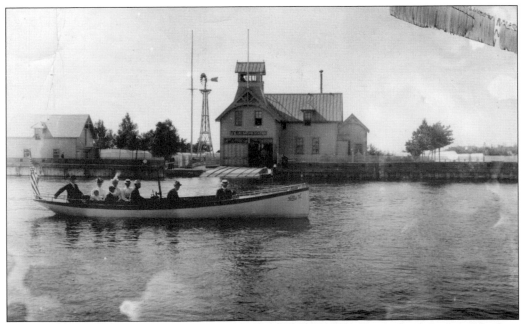

The Life Boat Station was also a majestic landmark that could be enjoyed as boaters made their way through the channel. (MCM)

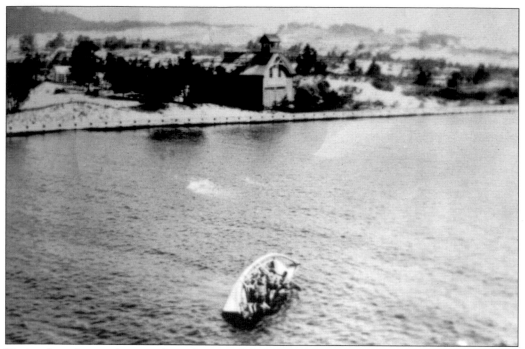

To simulate the conditions of a real rescue, life savers practiced rolling their lifeboat over to see how fast they could right it and get in again. It was not uncommon for life boats to be tipped over during rescues in stormy waters. (MCM)

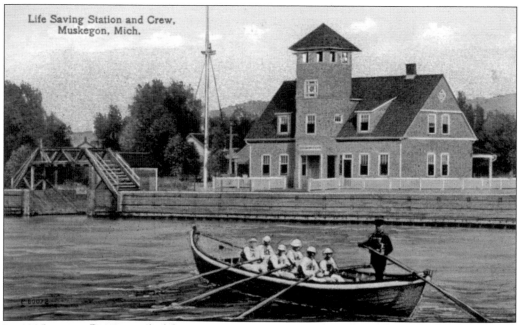

Life Saving Station and Crew, Muskegon, Mich.

In 1905 a new Racine style life-saving station was built on the south side of the river. The architectural style of this building was uncommon. Only one other station on Lake Michigan had the same design. This stately building was covered with wood shingles and had a four-story square lookout tower rising from its center. (MCM)

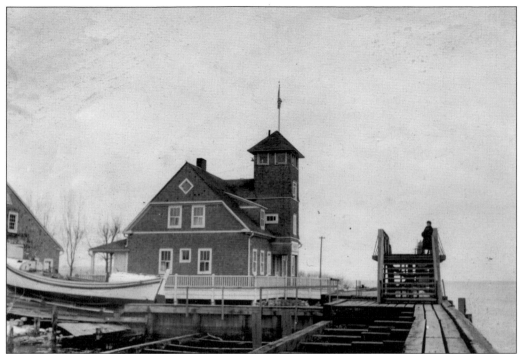

The new life-saving station had a separate boat house built next to it. The inclined platform in front of the boat house made it easier to launch the boat quickly in emergencies. (MCM)

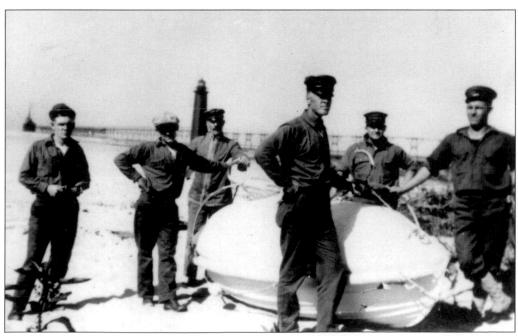

The lifecar was later used by the Coast Guard for rescue attempts. It held about 4 people lying down and was pulled across the water on a line, similar to the breeches buoy. The benefit of the lifecar was that it was totally enclosed, so passengers couldn't be washed out or dumped into the water. (MCM)

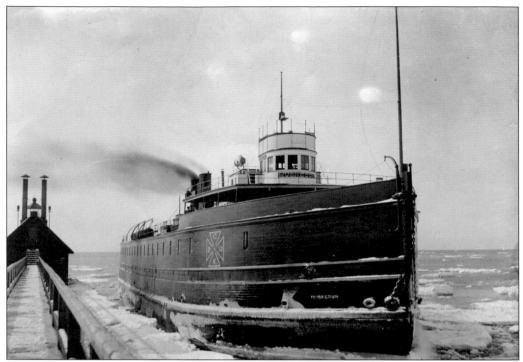

The car ferry *Muskegon* made its first round trip to Milwaukee in December of 1897. The *Muskegon* was a railroad car ferry, carrying railroad cars to their destinations. In this 1899 picture the *Muskegon* passes the fog signal building and the wooden pier as it enters the channel in the icy waters. (MCM)

This early 1900s photo shows a lumber schooner passing a light and bell tower on a wooden north pier as it travels through the channel near Muskegon Lake. The new Life-Saving Station can be seen on the south side of the channel. (MCM)

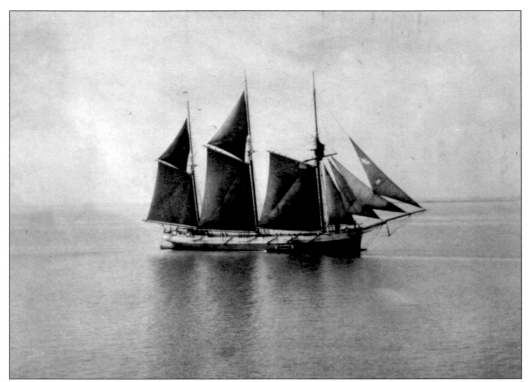

Built in 1875, *Our Son* was reportedly the last lumber schooner to sail into the Muskegon harbor. She carried lumber in the area until she foundered and sank in a storm many years later. (MCM)

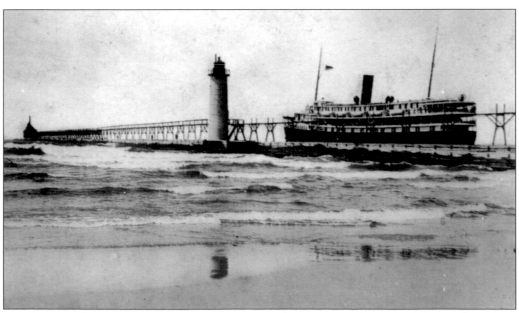

In 1903, a conical steel tower was added to the south pier. The light in this tower and the light of the fog signal building together formed a range light system. A catwalk connected the fog signal building and the tower to shore. (MCM)

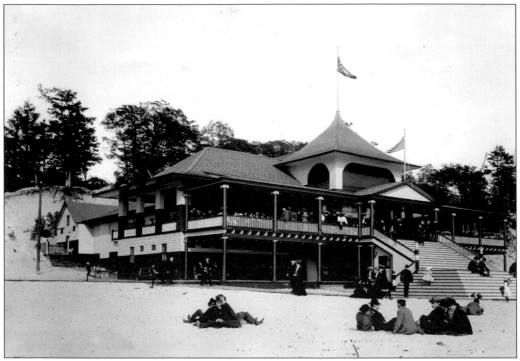

In 1890, the Traction and Lighting Company bought 20 acres of land along the beach to the south of the lighthouse and built Lake Michigan Park. The Pavilion at the park offered a large sitting deck, a bath house, and a dance floor. (MCM)

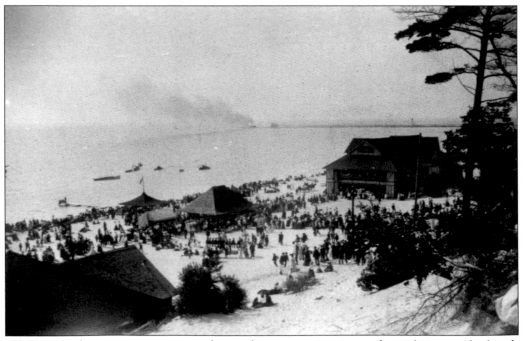

While sunbathing was not common during this time, swimming and socializing on the beach or in the beautiful new pavilion were very popular. (MCM)

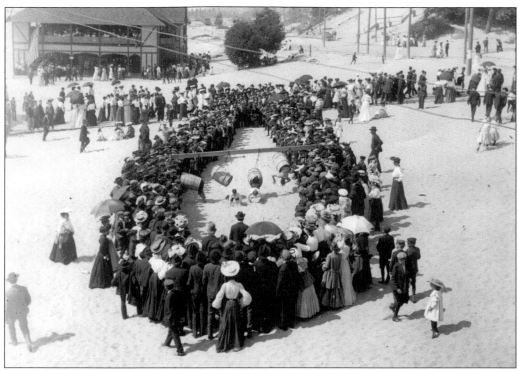

Competitions at group outings and company picnics often drew large crowds of spectators. (MCM)

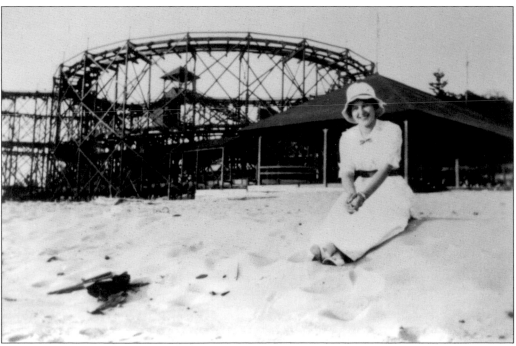

The "Figure 8" roller coaster was added to Lake Michigan Park c. 1907. People anxiously awaited the arrival of this popular attraction. (MCM)

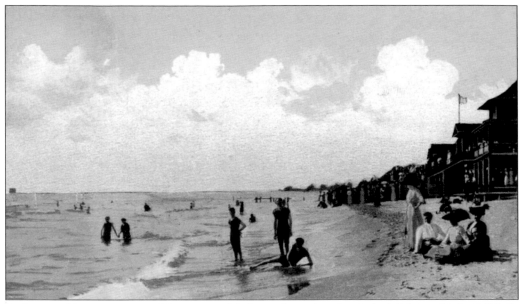
Bathers could enjoy a view of the piers and light as they relaxed at Lake Michigan Park. (MCM)

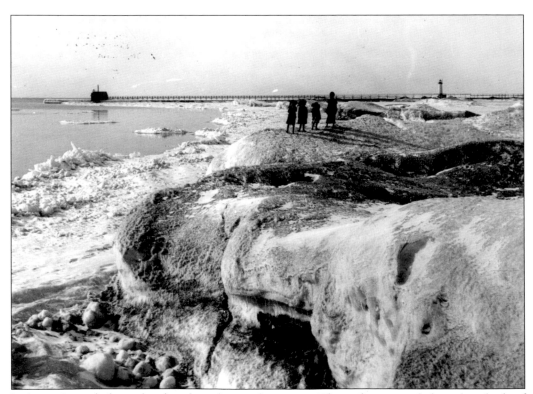
Icebergs formed along the shoreline during the winter. They often extended out hundreds of feet from shore and offered walkers a perspective of the light that was different from other seasons of the year. (MCM)

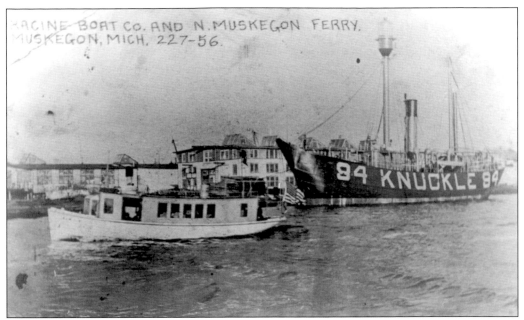

The lightship *Knuckle*, seen in the Muskegon Harbor, was built in Muskegon in 1910. Lightships were anchored as warnings in hazardous waters where a lighthouse had not yet been built or where it was not practical to build one. A lightship had a crew and was equipped with a tall light and sometimes a warning bell. (MCM)

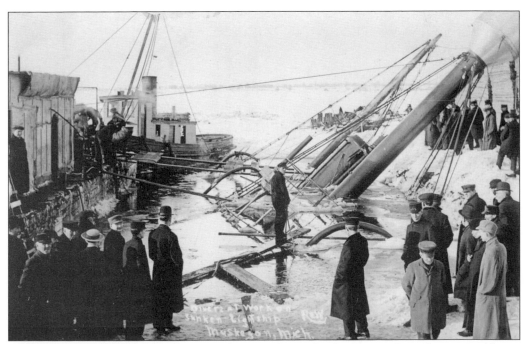

Many of our nation's lightships were built in Muskegon by the Racine Boat Company. Above, a lightship that sank in the Muskegon Harbor is being raised by a tugboat. (MCM)

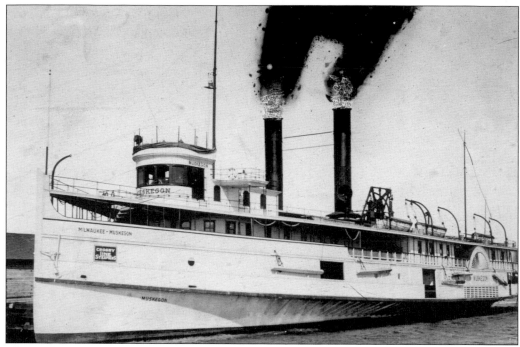

The crash of the sidewheeler *Muskegon* was one of the worst shipwrecks in Muskegon's history. On October 28, 1919 a strong northwest gale lifted the boat out of the water and slammed it into the south pier. The crew tried to get the passengers off the boat but most of them were trapped behind doors held shut by water pressure. Sadly, 31 lives were lost in this tragedy. (TCHM)

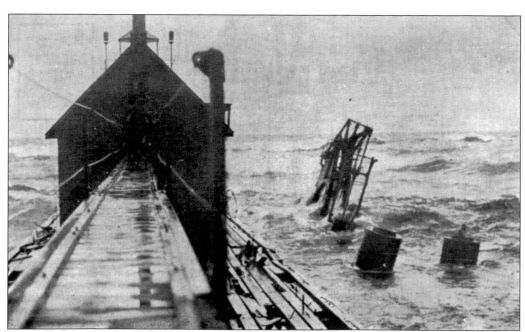

Large pieces of the boat can be seen near the fog signal building. Some of the wreckage stuck straight up through the wooden pier. (MCM)

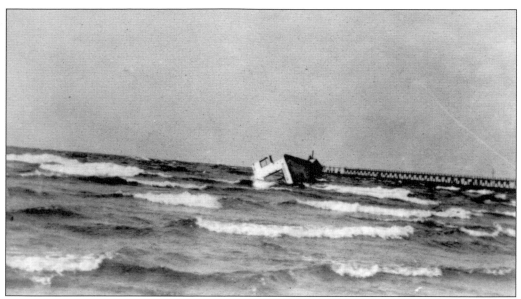

Wreckage from the *Muskegon* was found strewn on the beach two miles away from the pier. (MCM)

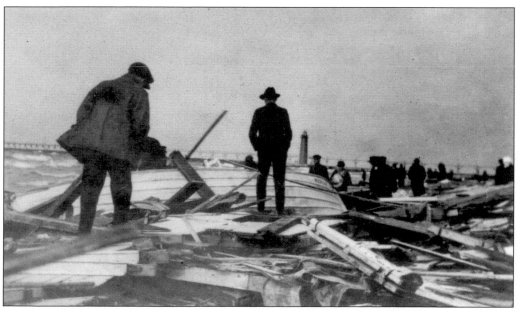

Many people from nearby towns came out to view the sight and salvage food and clothing from the remains. (MCM)

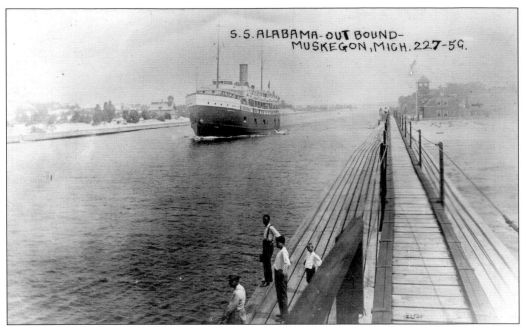

The passenger ship *S.S. Alabama*, of the Goodrich Transport Line, passes the Coast Guard Station as it leaves the serene waters of the harbor, bound for Chicago. (MCM)

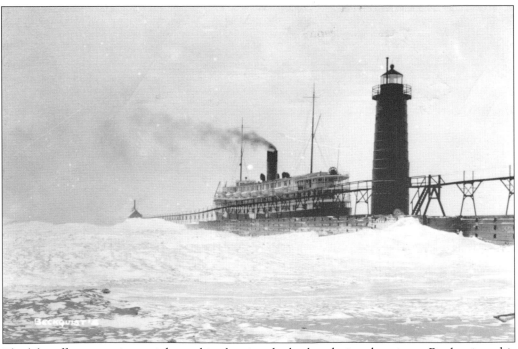

The lake offers an ominous sight to ships leaving the harbor during the winter. By the time this picture was taken in 1924, the conical tower had been painted red. (MCM)

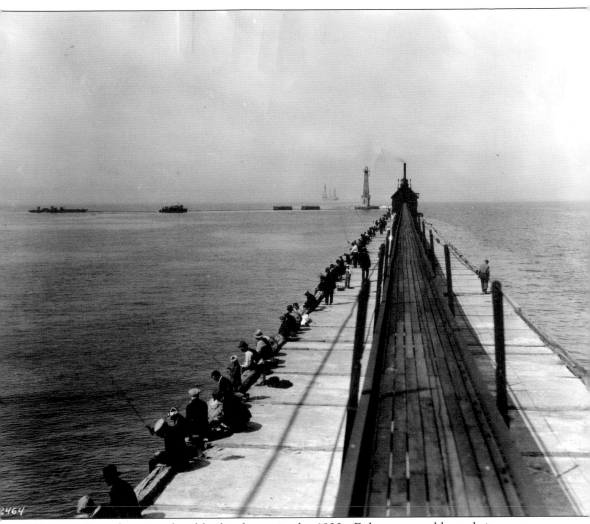

Construction of an arrowhead harbor began in the 1920s. Fishermen could watch its progress as they lined the pier waiting to make their catch. (MCM)

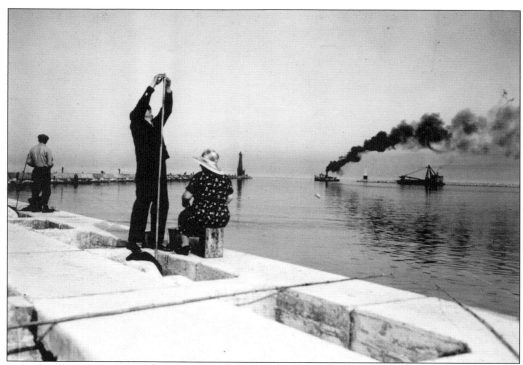

A gentleman helps his lady friend with her fishing pole on the south pier while work continues on the north side of the pier. (MCM)

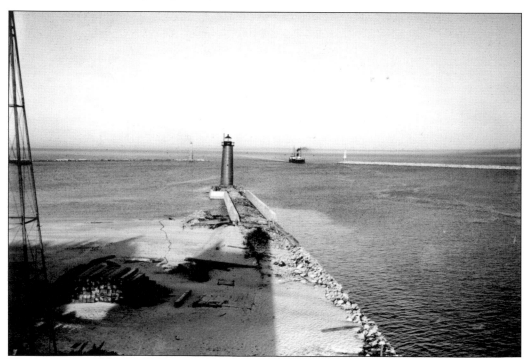

The south arm of the breakwater with its light was not fully completed until c. 1930. The north arm was completed in 1931. (MCM)

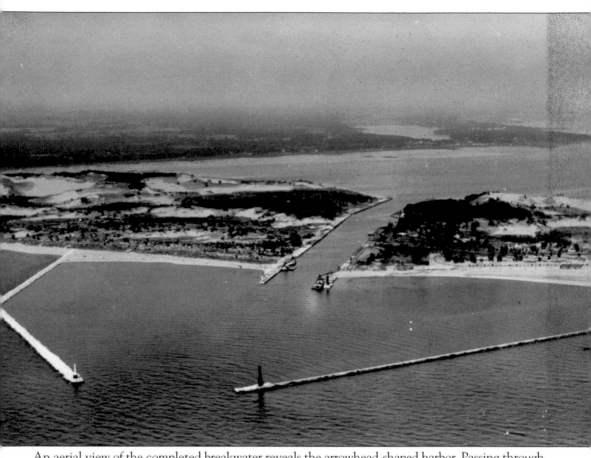

An aerial view of the completed breakwater reveals the arrowhead-shaped harbor. Passing through the calming basin and the channel, vessels make their entrance into Muskegon Lake. (MCM)

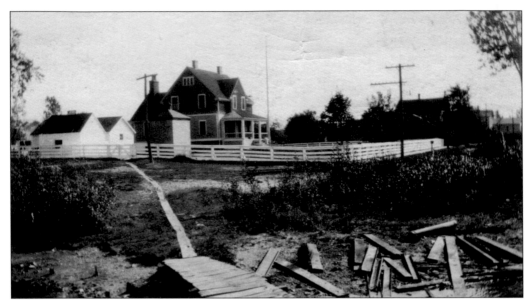

The shore-based lighthouse of 1870 was enlarged and moved to the south side of the channel near the Coast Guard Station in 1930. (MCM)

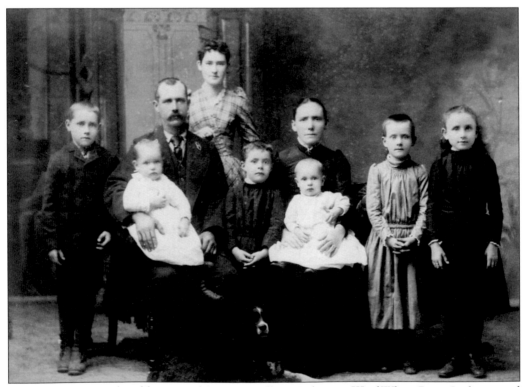

Thomas Robinson, the oldest son of Captain William Robinson III of White River Light, served as keeper of the Muskegon lights for about 20 years. With the Muskegon Lake lights and the Muskegon Harbor lights together, he had a total of six lights under his care at one time. Keeper Robinson lived in the shore-based house with his wife JoHanna and their children. (JH)

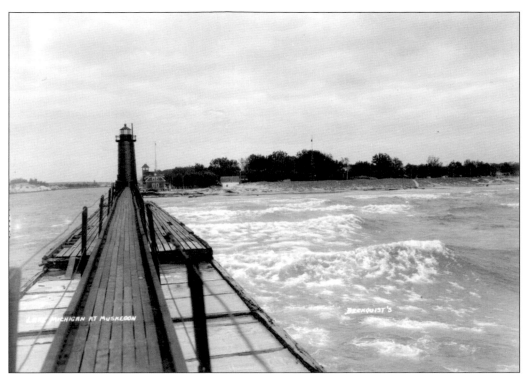

This view looks in toward the harbor from Lake Michigan c. 1930. The conical tower and the Coast Guard Station are behind. (MCM)

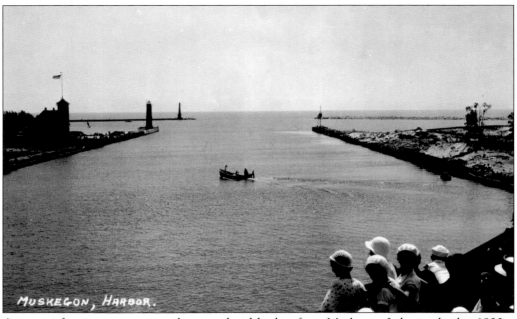

A group of excursionists view the arrowhead harbor from Muskegon Lake in the late1930s–1940s. Pleasure boaters in Muskegon Harbor could take advantage of both lakes. They could sail the smaller Muskegon Lake for a while, then go out the channel and enjoy the challenge of the much larger Lake Michigan. (MCM)

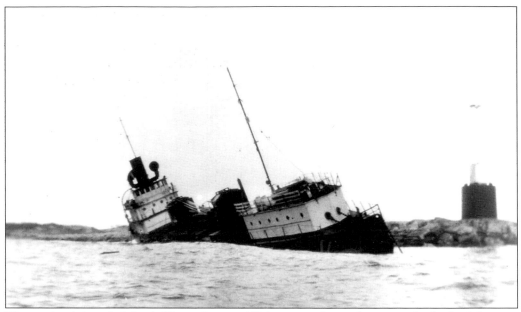

The crash of the whaleback *Henry Cort* in 1934 was another sad time in the harbor's history. Built in the 1890s, the *Cort* had suffered several mishaps during her years of service on the Great Lakes. In fact, only a year before the disaster in Muskegon she had sunk and was raised and rebuilt. At Muskegon harbor, she was loaded with 600 tons of steel and got caught in a heavy gale that smashed her into the north pier. (MCM)

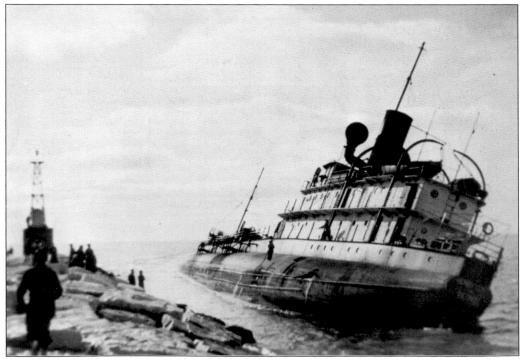

All of the crew members and some of the cargo of the *Cort* were saved. However, one Coast Guard member lost his life during the rescue. (MCM)

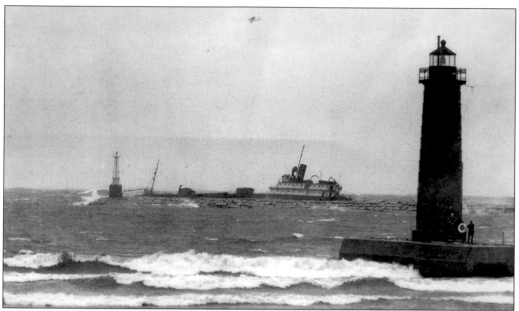

The *Cort* remained at the pier for two weeks until her bow broke off and sank. Eventually, she was declared a hazard to other ships and was dynamited. (MCM)

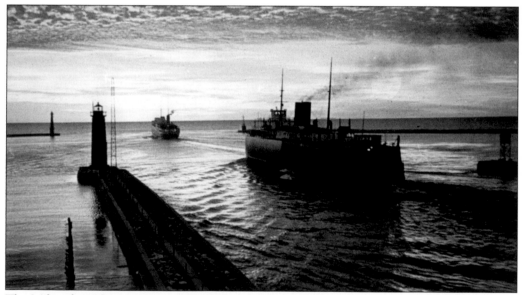

The *Milwaukee Clipper* was a popular ferry boat that ran between Muskegon and Milwaukee in the 1940s. She began her career as a Great Lakes passenger steamer in 1905 and was remodeled and converted to a cross-lake auto and passenger ferry in 1941. Pictured above, she is the first boat leaving the harbor. (MCM)

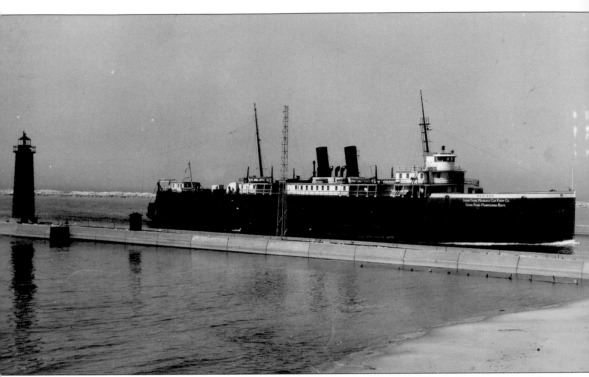

Pier reconstruction took place in the 1950s, making the necessary improvements for modern freighters that were entering the harbor. (MCM)

Seven

WHITE RIVER
LIGHT STATION

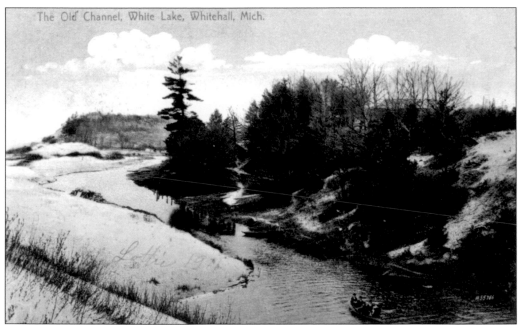

The cities of White Hall and Montague lie at the west end of the White River, which connects to Lake Michigan through White Lake. In the early 19th century this area was thick with pine forests and, like its neighbors to the south, White Lake Harbor became an important lumbering port.

The first sawmill on White Lake became operational in 1838. Because the old natural channel was shallow and curvy, floating logs from the sawmill to Lake Michigan was a slow, tedious process. Rafts of logs had to be pushed along the river with poles or pulled by teams of oxen.

Early requests for funds for harbor improvements went unanswered by Congress. It was not until after the Civil War, when industrialization was sweeping the nation and the demand for lumber was soaring, that Congress approved the necessary funds for the project. A straighter, deeper channel was eventually cut through to Lake Michigan. The improved harbor was completed just in time to meet a new demand for lumber resulting from the Chicago fire of 1871. (MCM)

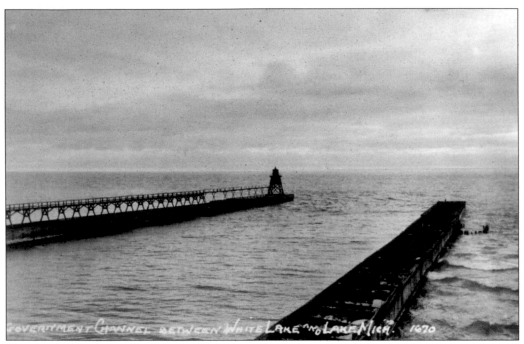

Shortly after the new channel was built, a small wooden tower light was placed on the end of the south pier. About four years later an elevated foot-walk that ran the length of the pier was also added. (MCM)

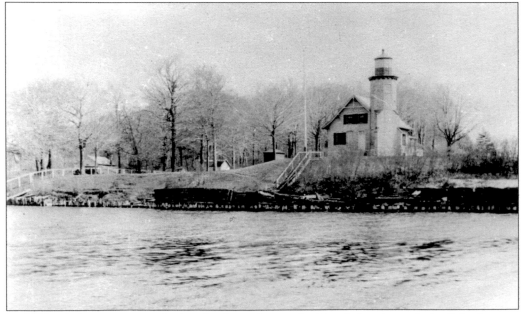

In 1875 a light station was built inland on the south side of the channel. Its light became operational in time for the beginning of the 1876 shipping season. The station contained living quarters for a keeper and his family. (MCM)

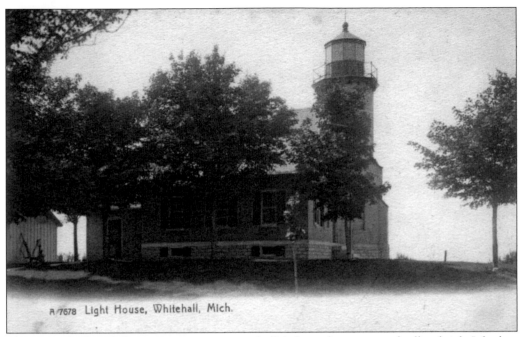

A 7678 Light House, Whitehall, Mich.

The quaint-looking light station was constructed of Michigan limestone and yellow brick. It had an attached octagonal tower with a cast-iron spiral stairway that led to the lantern room. (MCM)

The lantern room held a Fourth Order Fresnel lens. Developed in 1822 by French physicist Augustin Fresnel, the lens used a series of glass prisms to reflect and magnify the light, causing its beam to shine farther across the water. Classification of the lens ranged from First Order to Sixth Order based on its size and focal length. The largest First Order lens stood twelve feet tall and the smallest Sixth Order lens measured just under two feet. Generally, the smaller Fourth through Sixth Order lenses were used on the Great Lakes.

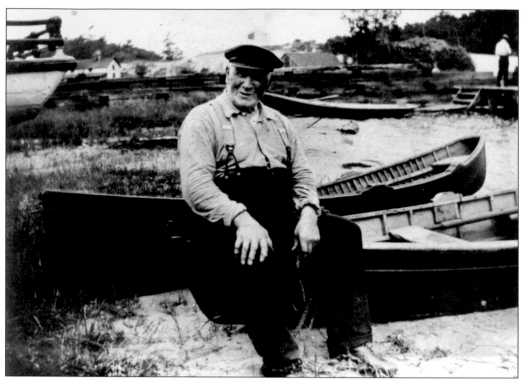

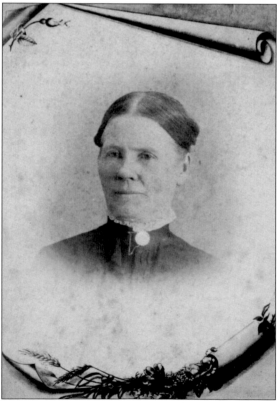

The fame of the White River light rests on its first keeper, Captain William Robinson III. Having had much experience on the sea, he knew how important it was to mark harbor entrances. He took it upon himself to keep a fire burning at the White River entrance even before the light came into existence. He was instrumental in building both the pier light and the light station, and became the first keeper of these lights and the first keeper to live in the light station. (MCM)

Captain Robinson and his wife, Sarah, moved from England to Michigan in 1867. Together they had 13 children, 11 of whom survived to adulthood. The captain was grief-stricken when his wife died at the light station in 1891. (JH)

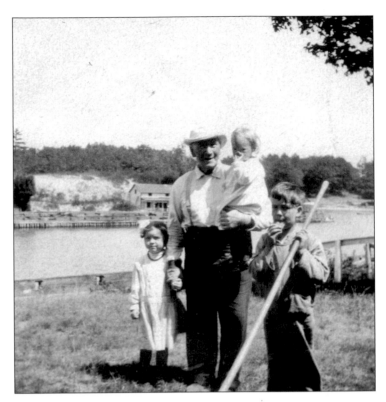

The Captain and his great grandchildren take a break from doing yard work on the lighthouse grounds. Pictured from left to right are: Loretta, Captain Robinson, Myra, and William Bush. (JH)

Having a large family meant there were often visitors at the lighthouse. Two family members pose for a picture in front of the tower during one of their visits. (JH)

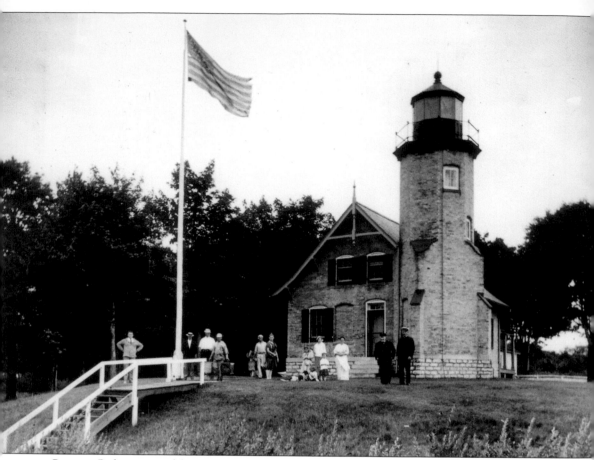

Captain Robinson and his son, Thomas (at right), overlook the channel with some visiting friends. Thomas Robinson was assistant keeper under his grandfather and later became keeper at the Muskegon light. (JH)

Opposite, Top: The Captain, seated, is shown with three of his sons at the station. His sons are, from left to right, Thomas, George, and Williamson. Many of the captain's sons and grandsons grew up to work for the lighthouse service or serve in the U.S. Coast Guard. (JH)

Opposite, Bottom: The captain enjoyed spending time with family members. Pictured from left to right are: (front row) the captain's great grandson, William R. Bush; (second row) unidentified, the captain's great-granddaughters, Myra and Loretta Bush; (back row) unidentified, Captain William Bush, Captain Robinson, Rebecca Bush (William's wife), and unidentified. (JH)

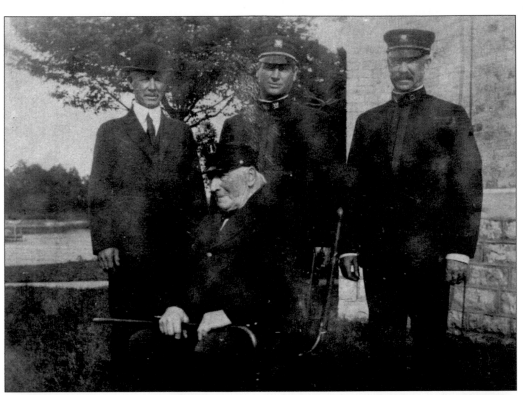

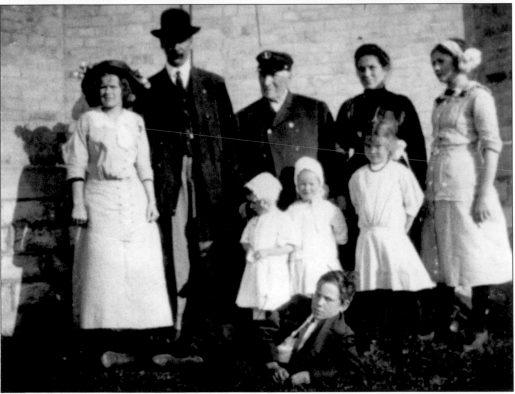

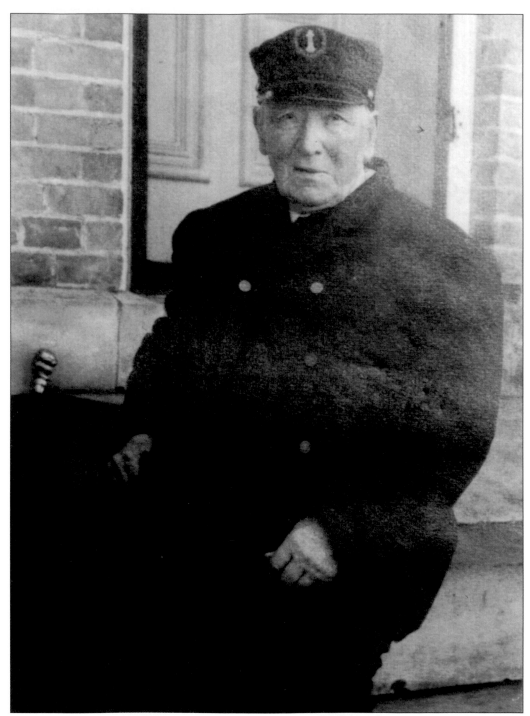

Captain Robinson served for 47 years at the White River light, making him one of the oldest and longest-serving keepers in Michigan when he retired. He is credited with saving many lives during his years of service. At 88 years of age, he was forced to retire because his duties became too demanding for him. This news was very distressing to him, and he ultimately died in the lighthouse shortly before he was to move out. (JH)

William E. Bush was assistant keeper under his grandfather at the time of his grandfather's death in 1919. After the loss of Captain Robinson, William was appointed second keeper of the light station, keeping the family tradition alive.

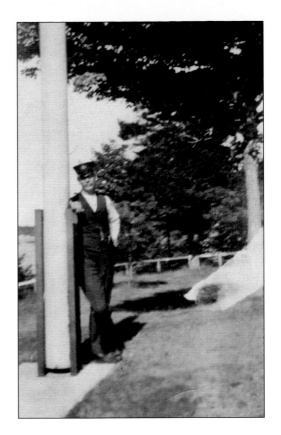

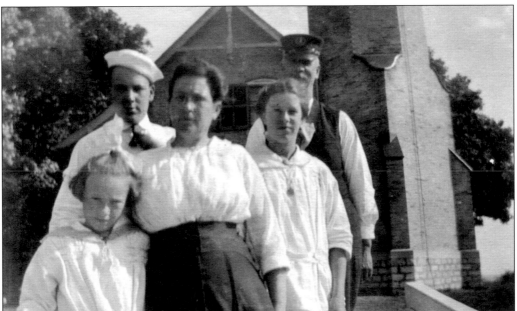

Captain William E. Bush and his wife Rebecca had three children. Shown standing in front of the light station, from left to right, are: (front row) Myra, Rebecca, and Loretta; (back row) William R. and William E. Bush. (JH)

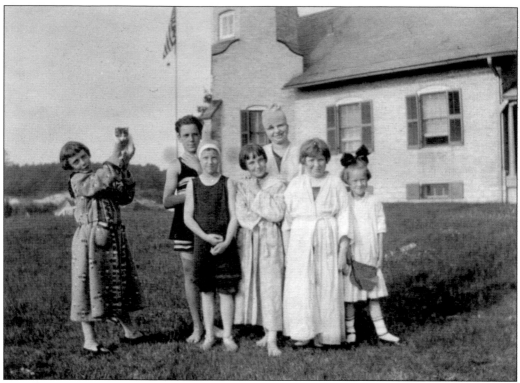

Friends of the Bush children enjoyed stopping at the lighthouse and going for a swim in the Lake. In the front row, daughter Loretta stands on the left and her younger sister Myra is on the far right. Son William R. is the only boy in the picture, standing on the left in the back row. (JH)

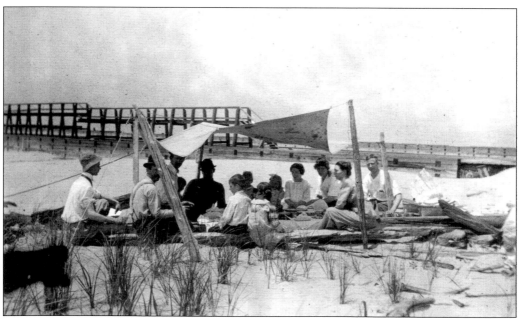

Members of the Bush family take time out from their work to enjoy a picnic on the beach, overlooking the foot-walk. (JH)

Jeanette, Captain Bush's granddaughter—and Captain Robinson's great-great-granddaughter—liked riding her tricycle on the lighthouse grounds when she came for a visit. (JH)

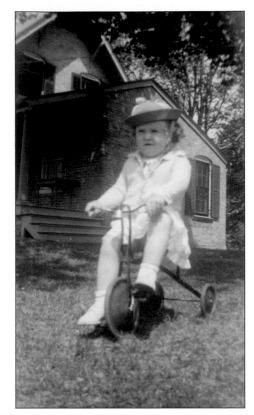

Three generations of Bushes pose for a picture at the light station. In the front row is granddaughter Jeanette, and from left to right in the back row are grandparents William E. and Rebecca Bush and their daughter, Loretta. (JH)

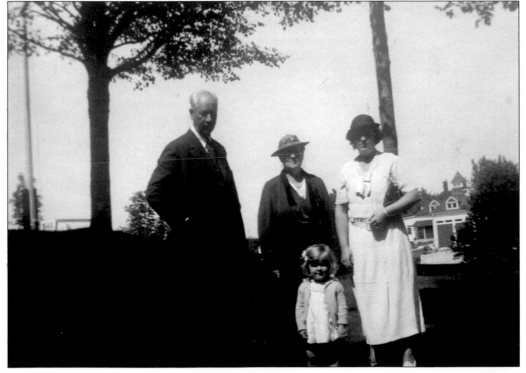

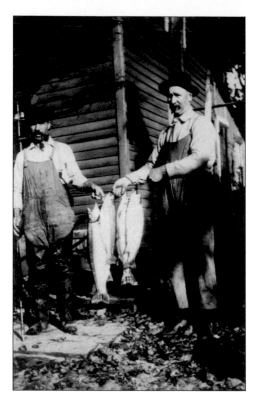

With the great resource of Lake Michigan in their back yard, fishing was not only fun but was also a good way to stretch the food allotment given to lighthouse keepers. A friend, Mr. Johnson (at left), and Captain Bush (at right) display their catch of the day. (JH)

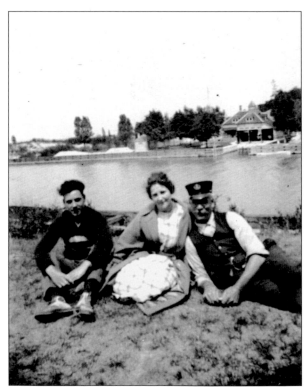

Captain Bush relaxes with his wife and son William (?) on the lighthouse lawn. Across the channel on the north side stands the U.S. Coast Guard building. (JH)

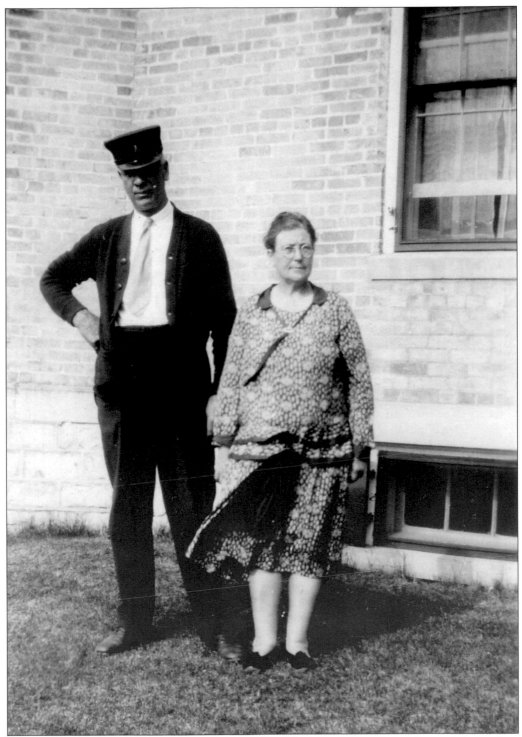

William and Rebecca Bush lived at the lighthouse for 23 years. For eight of those years, William was the assistant, and for 15 years he served as the keeper. The Bushes left the lighthouse when William retired in 1943. (JH)

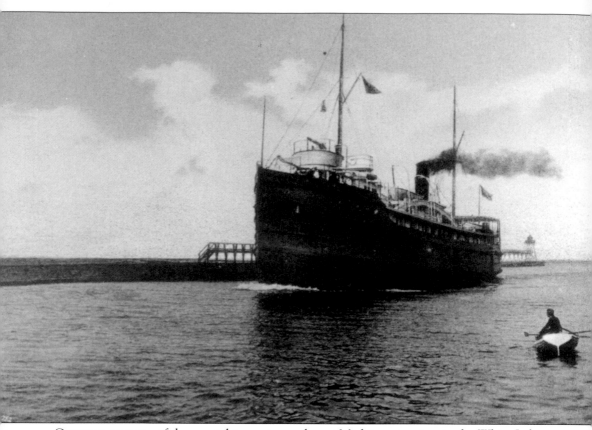

Common to many of the coastal towns in southwest Michigan, tourism in the White Lake area was heavy during the late 1800s and early 1900s. Passenger ships trafficking the harbor were a common sight. (JH)

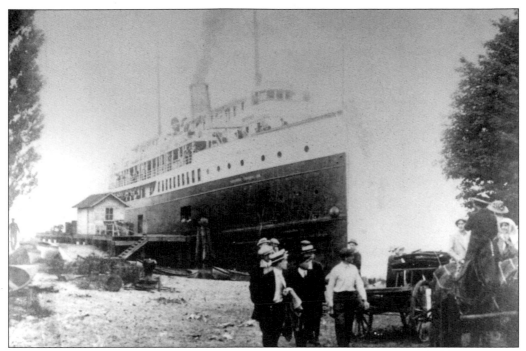

The Goodrich steamship, *Carolina*, shown at the Michillinda Dock on White Lake, began carrying passengers between White Lake and Chicago in 1906. (JH)

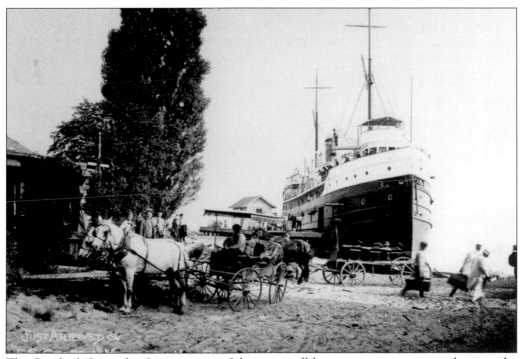

The Goodrich Steamship Line was one of the most well-known passenger carrying lines on the Great Lakes, and several ships in its fleet came into White Lake. The steamship *Georgia* also docked at the Michillinda dock. (JH)

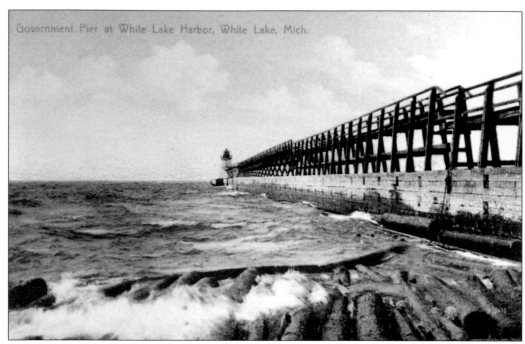

Government Pier at White Lake Harbor, White Lake, Mich.

In the early 1900s, the wooden foot-walk was rebuilt with cast iron. However, after continual repairs caused by ice and fire damage and ships colliding with it, the foot-walk was demolished in 1925. (MCM)

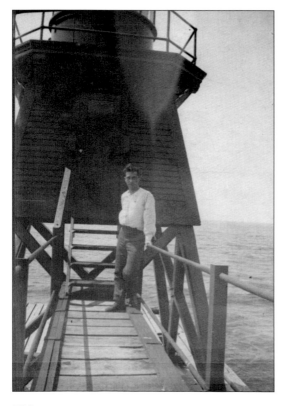

The south pierhead light was painted red in 1917. The following year an electrical cable was run under the channel and an electric light was installed in the tower. (JH)

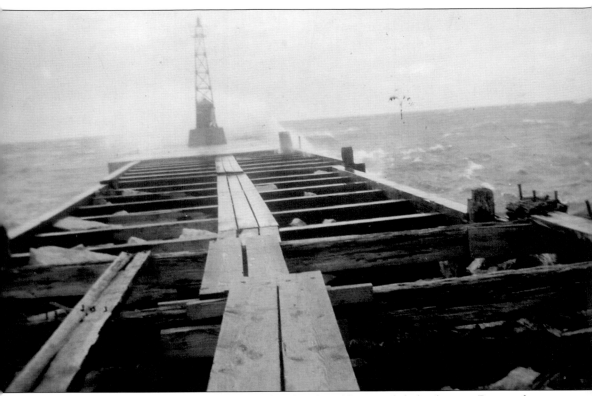

In 1930, the old pierhead light was dismantled and replaced by a steel skeletal tower. During the same year, the north and south piers were rebuilt with stone and faced with concrete. (JH)

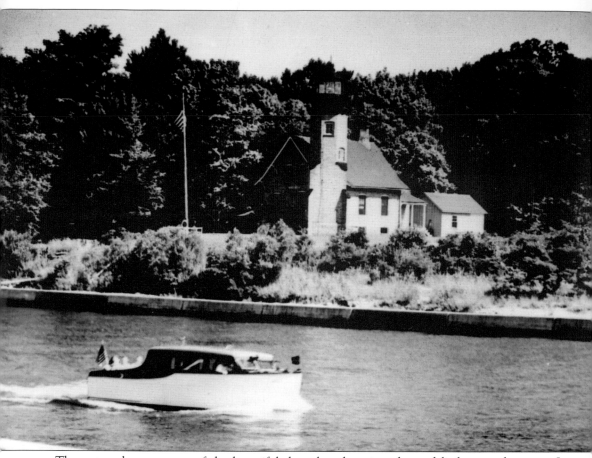

The outward appearance of the beautiful shore-based station changed little over the years. In 1960, the station was decommissioned and the light was removed from its tower. The station was later purchased by Fruitland Township to be used as a museum. (State Archives of Michigan.)